D0129142

Oakland

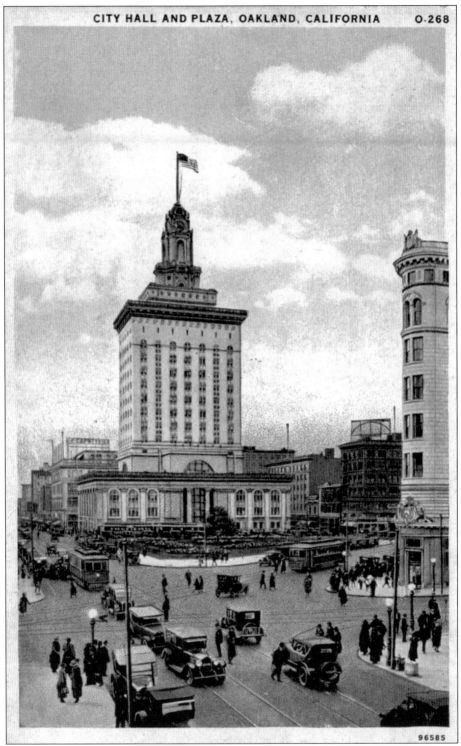

96585

CITY HALL AND PLAZA, C. 1925. This intersection at Fourteenth Street and Broadway is the heart of downtown Oakland.

POSTCARD HISTORY SERIES

Oakland

Annalee Allen

Copyright © 2005 by Annalee Allen
ISBN 0-7385-3014-X

Published by Arcadia Publishing
Charleston SC, Chicago IL, Portsmouth NH, San Francisco CA

Printed in Great Britain

Library of Congress Catalog Card Number: 2005926952

For all general information contact Arcadia Publishing at:
Telephone 843-853-2070
Fax 843-853-0044
E-mail sales@arcadiapublishing.com
For customer service and orders:
Toll-Free 1-888-313-2665

Visit us on the internet at http://www.arcadiapublishing.com

CONTENTS

ACKNOWLEDGMENTS

I would like to acknowledge, first and foremost, Ed Clausen, for allowing the use of his remarkable collection of historical postcards. I am very appreciative of his generous time, spent selecting the images for this book, offering helpful suggestions, providing the answers to a hundred obscure questions, and, most importantly, agreeing to scan each and every postcard image. Thank you, Ed.

And Ed would like to thank Chris Oien, "the South Dakota chiropractor and family computer whiz," who, Ed says, "solved the problem of the recalcitrant scanner in the nick of time."

Thank you Betty Marvin and Gail Lombardi, of the city's Cultural Heritage Survey, where all the files are organized on all of the buildings and districts of Oakland. You were incredibly helpful and patient with all my questions.

Thanks to Steve Lavoie of the Oakland History Room of the Oakland Library. As always, the history room files are remarkable resources for any historical research project.

Thank you, Dennis Evanosky, for helping me understand the ferries and the Oakland waterfront; you were a tremendous help.

Oakland, The Story of a City, by Beth Bagwell, is the essential text on Oakland's remarkable history. I enjoyed rereading the book and appreciating it all over again; how incredibly thorough Ms. Bagwell was in covering so many aspects of the city's 150-year history.

The collected issues of the Oakland Heritage Alliance Newsletter were invaluable as a resource. I was able to find many answers to questions in the newsletter, a publication with 25 years worth of articles about Oakland, written by dedicated volunteers.

I must thank Chris Treadwell of the *Montclarion* and Peggy Stinnett of the *Oakland Tribune*, who both offered me the opportunity to contribute columns about Oakland's history, starting back in 1993. I was able to refer to my own portfolio of articles for information included herein.

Lastly, thank you Jim, my patient and forbearing husband; your support means everything to me.

INTRODUCTION

Viewing historical postcards can be like taking a journey back in time. Retired Oakland firefighter Edmund Clausen has a postcard collection of his hometown that provides an opportunity to take such a journey. Ed estimates that since 1978, when he acquired his first card of the Montgomery Ward mail order store on East Fourteenth Street (see page 56), he has amassed 6000 postcards of Oakland, and he doesn't expect it will end there. He has organized the cards by specific categories in some 25 binders, and when asked to produce an image of a long-lost street scene or landmark, Ed can find that particular binder in no time.

Choosing just 230 images for an Oakland postcard book from Ed's collection was a challenge. When asked to name his favorites, Ed diplomatically comments, "Well, they are all like my children, so please don't ask me to choose."

Tracing the history of postcards leads back to the 1893 Columbian Exposition in Chicago, where one-cent, printed cards could be purchased and mailed throughout the world. In 1907, Congress authorized a new type of card—the "divided back"—where the writer could place a message on one half, and the address on the other, on the reverse side of the card.

As time went by, Ed discovered that many of the Oakland cards he was collecting were produced in the first decades of the 20th century. Those were particularly exciting years in Oakland's history, Ed notes. Downtown's appearance was changing from the earlier era of horse buggies and gas lit lamps, to high-rise "skyscrapers" being built up and down Broadway. Industry and transportation networks were taking hold and gracious homes on tree-lined avenues were sprouting up next to electric streetcar lines. Stately churches, schools and clubs, designed by talented architects (including American's first licensed woman architect, Julia Morgan) were appearing throughout the city. A haven for thousands of refugees displaced by San Francisco's 1906 earthquake disaster, Oakland experienced a brisk building boom unequaled in its history during this period, say the history files.

During these decades of growth and expansion, two dynamic elected leaders, each with his own unique personality, emerged to guide the city's progress. Frank K. Mott, a self-made man, hardware store owner, and telephone operator (said to be the city's first) was mayor from 1905 until 1915. John L. Davie, who followed Mott's administration, was a larger-than-life character, a former mule skinner, cattle driver, butcher, opera singer, book seller, and ferry-boat operator. Davie served four successive terms at city hall, and finally retired in 1931, at the age of 81. During the 30-year period under mayors Mott and Davie, Oakland expanded in size (annexing an additional 44 square miles by absorbing nearby townships east of Lake Merritt) and more than doubling its population from 66,000 in 1900 to over 150,000 in 1920.

The progressive-minded Mott (1866-1958) was influenced by the so called "City Beautiful Movement," say the history files, a grand concept for ideal urban development called for by city planners throughout the nation, during the early 20th century. This progressive philosophy

called for city leaders to aspire to grand boulevards and plazas, civic centers, and imposing public buildings. It called for public funds to be allocated for parks, museums, and libraries. Modern cities should have adequate fire and police protection. Sewage systems should be in place and safe drinking water should be available. Health care and hospitals should be there for all, not just for those who could afford to pay. Under Mayor Mott, Oakland made great strides in all these areas.

His successor, Mayor Davie (1850–1934), was also a tremendous booster for Oakland, overseeing the establishment of the maritime port and an airport facility (one of the first in the nation), as well as the creation of a publicly controlled water district, and the opening of a regional parks system. Industries and manufacturers attracted to Oakland because it was the city where "rail, road, and water met," opted to become established in the East Bay during Davie's tenure. Oakland became the "Detroit of the West," when Chevrolet and General Motors opened assembly plants here. Food processors, canneries, cotton mills, and machinists developed business sites in Oakland's flatland districts, in proximity to the rail and shipping lines.

Commuters with financial or insurance-related jobs in San Francisco could find affordable homes to buy, close to reliable street cars with convenient ferry connections during this period as well. Numerous schools and institutions of higher learning were close at hand, and houses of worship attracted large congregations. Performances, concerts, and movies took place at the city's magnificent municipal auditorium, its bandstands, and its movie palaces. Perhaps most of all, the postcards reveal, Oaklanders could take pride in their sparkling, man-made lake (thanks to Samuel Merritt, another visionary mayor) in the very center of the city, surrounded by elegant homes, apartment buildings, and civic landmarks.

Since retiring from the fire department, where he spent his career of 31 years, Ed has been enjoying his interest in local history by serving on the board of the Alameda County Historical Society, and the Dunsmuir House and Gardens. Most importantly, he hasn't stopped looking for more Oakland postcards.

One

EARLY OAKLAND

The early days of Oakland can be traced back to 1850, the year California became a state. It is also the year when three former New Englanders, Edson Adams, Alexander Moon, and Horace Carpentier, entered into a lease for 480 acres next to a boat landing, along San Antonio Creek on the *contra costa* (Spanish for "the opposite shore") of San Francisco Bay. The land belonged to Vicente Peralta and was his portion of his family's 44,000-acre rancho, granted by the King of Spain 30 years earlier, in 1820.

The township's earliest residents numbered less than 100 and clustered near what is now the foot of Broadway. After Oakland was designated as the western terminus of the transcontinental railroad in 1869, steady growth and development took place for the next several decades.

Another important impetus to the city's evolution occurred as a result of the 1906 earthquake, due to several thousand of those displaced by the disaster deciding to resettle in Oakland and the East Bay. In 1935, some 80 years after the city was founded, Oakland had become the third largest city in California.

OAKLAND WATERFRONT.

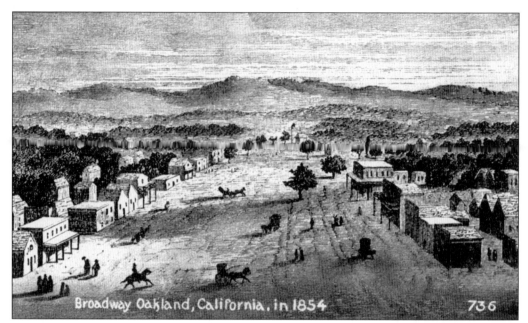

Broadway Oakland, California, in 1854 736

EARLY VIEW OF BROADWAY, 1854. The first city hall was a rented upstairs room on Third Street, used up until 1867. From 1867 until 1871, the second city hall was located in another rented room on Eighth Street.

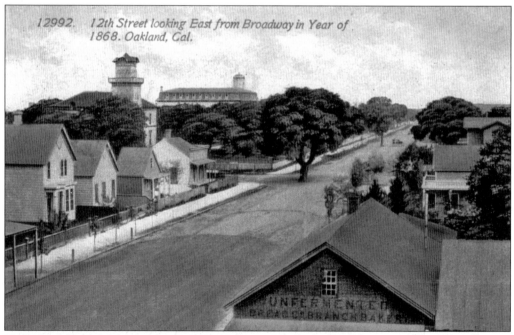

12992. 12th Street looking East from Broadway in Year of 1868. Oakland, Cal.

TWELFTH STREET, LOOKING EAST, IN 1868. The tower and large building behind the trees are part of the College of California, before it became a university and moved to Berkeley. The original campus extended from Twelfth to Fourteenth Streets and from Franklin to Harrison Streets.

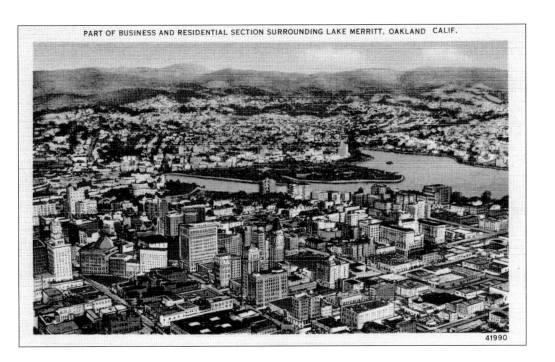

BIRD'S-EYE VIEWS OF OAKLAND, 1935. Downtown's tallest buildings are clustered along Broadway in the image above, which faces east toward the Oakland hills. Below, looking west, the newly completed bay bridge is visible in the distance.

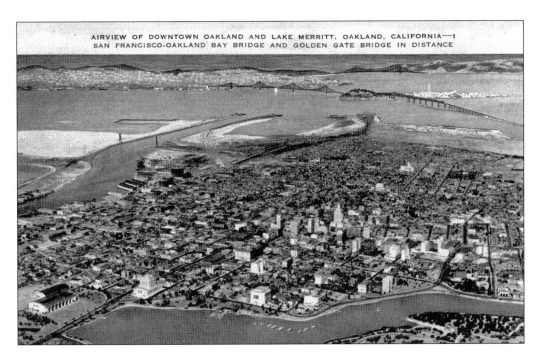

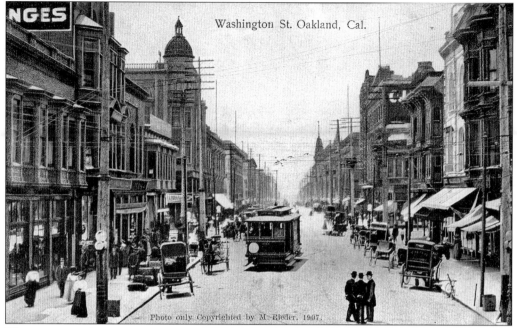

Washington St. Oakland, Cal.

Photo only Copyrighted by M. Rieder, 1907.

WASHINGTON STREET LOOKING SOUTH, C. 1875. Town founders Carpentier, Adams, and Moon called for a street plan to be laid out, and several blocks of Washington Street, one block west of Broadway, became the mercantile district.

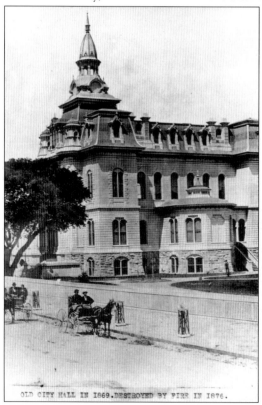

OLD CITY HALL IN 1869. DESTROYED BY FIRE IN 1876.

OAKLAND CITY HALL, NUMBER THREE. In 1871, S. C. Bugbee and Sons built a proper city hall (number three) facing Washington Street, at Fourteenth Street, with a mansard roof and a cupola 30 feet high. The jail was in the basement. It burned to the ground in August 1877, the work of a suspected arsonist during a period of civil unrest brought on by labor shortages.

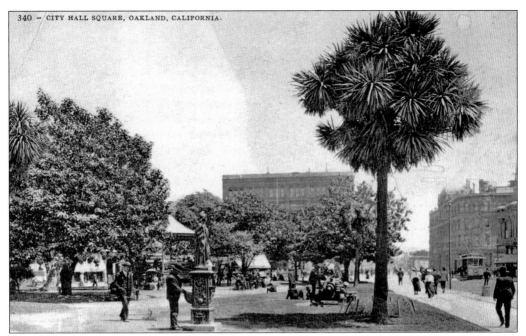

CITY HALL PLAZA. In 1868, the City acquired the triangular-shaped lot just east of city hall, over to Broadway. It remained a public space from that time forward.

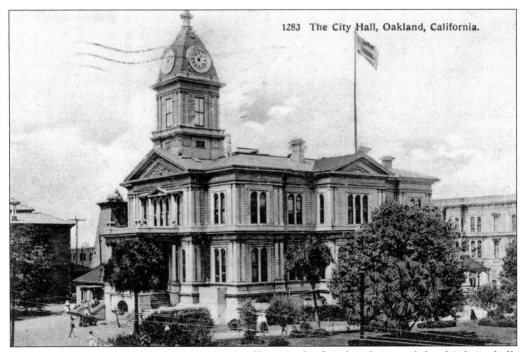

1283 The City Hall, Oakland, California.

OAKLAND CITY HALL, NUMBER FOUR. Following the fire that destroyed the third city hall, a new, very similar, wood-frame structure was built by the Newsom Brothers on the same site. It stood in place until 1914, when it was replaced by the fifth city hall.

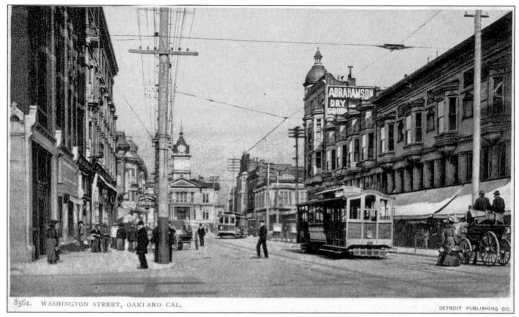

WASHINGTON STREET LOOKING NORTH, C. 1880. Streetcars were a fixture along Washington Street. In the 1890s, both Frank Mott and Frank Davie had businesses in the area before turning to local politics. Mott owned a hardware store, and Davie had a coal and feed business, with a bookshop next door that was frequented by Jack London, Joaquin Miller, and Ina Coolbrith, say the history files.

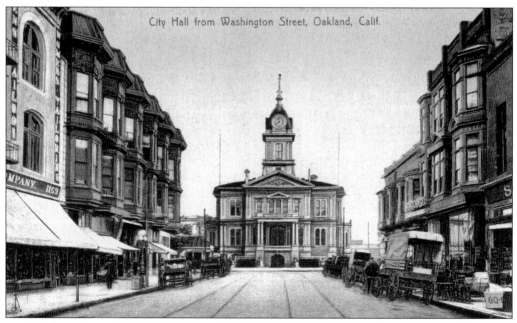

CITY HALL NUMBER FOUR FROM WASHINGTON STREET.

14

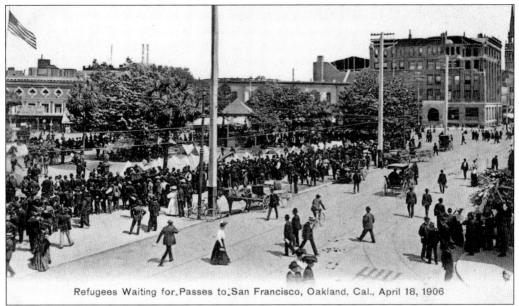

Refugees Waiting for Passes to San Francisco, Oakland, Cal., April 18, 1906

AFTERMATH OF THE 1906 EARTHQUAKE, CITY HALL PLAZA. Following the earthquake and fire of 1906, frightened citizens fled devastated San Francisco by the thousands. Once in Oakland, they were required to obtain a pass from Gov. George Pardee in order to go back across the bay. Pardee, an Oaklander by birth, traveled immediately from Sacramento to Oakland to direct the disaster response.

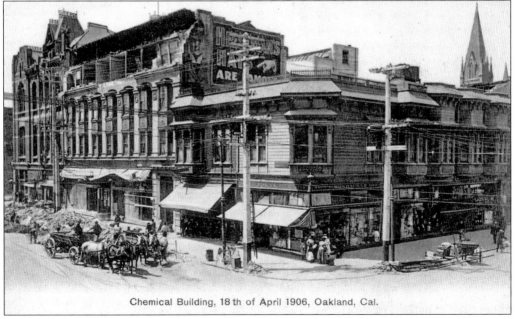

Chemical Building, 18 th of April 1906, Oakland, Cal.

AFTERMATH OF THE 1906 EARTHQUAKE, BUILDING DAMAGE. Although structures were damaged in Oakland, there were fortunately no fires, and life returned to relative normalcy within a short time. Oaklanders focused instead on helping the influx of suddenly homeless San Francisco refugees, setting up tent cities in Lakeside Park, Idora Park, and other places, and providing food, blankets, and clothing.

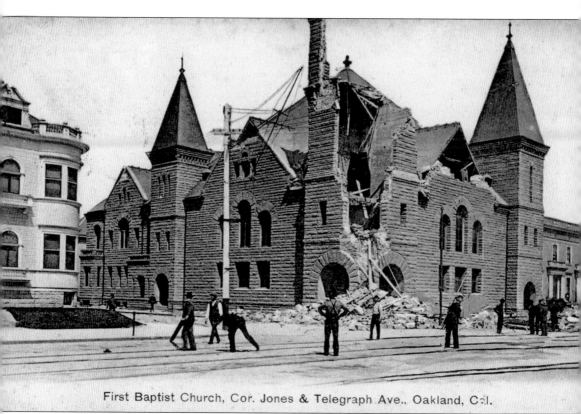

First Baptist Church, Cor. Jones & Telegraph Ave., Oakland, Cal.

DAMAGE FROM THE 1906 EARTHQUAKE, FIRST BAPTIST CHURCH. The First Baptist Church on Telegraph Avenue was one of the more visibly earthquake-damaged buildings in Oakland. Julia Morgan, recently returned from her studies in Paris, and the first California woman licensed to practice architecture, drew up the plans for the reconstructed interior of the church (see Chapter Six).

Two

Oakland Civic Pride and the City Beautiful Movement

As the 20th century dawned, Oakland entered the modern era under the leadership of Mayor Frank K. Mott. Mayor Mott energetically led the campaign to convince voters to approve millions of dollars in bond measures to pay for a new "skyscraper" city hall, as well as a lakeside municipal auditorium and upgrades to the fire and police departments. The acquisition of parks and playgrounds, boulevard improvements around Lake Merritt, and the establishment of a public museum also occurred during Mott's tenure as mayor.

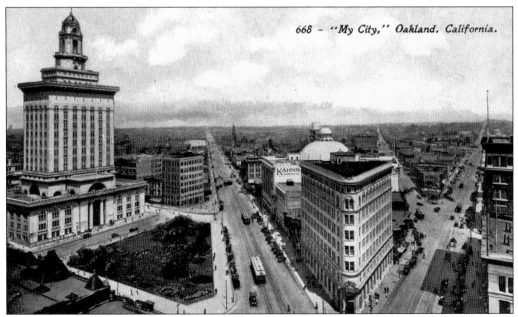

668 – "My City," Oakland, California.

CITY HALL PLAZA, C. 1915.

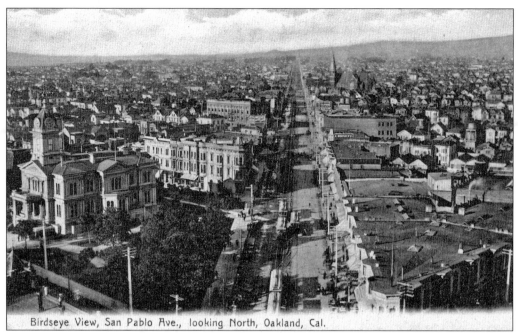

Birdseye View, San Pablo Ave., looking North, Oakland, Cal.

LOOKING NORTH FROM CITY HALL PLAZA, C. 1900. In 1900, development was well underway north of Fourteenth Street and Broadway. In this view, San Pablo Avenue stretches to the north, towards Berkeley. The spire of St. Francis de Sales Catholic Church is visible in the distance.

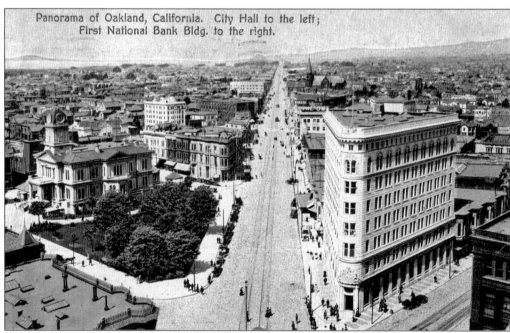

Panorama of Oakland, California. City Hall to the left; First National Bank Bldg. to the right.

LOOKING NORTH FROM CITY HALL PLAZA, C. 1905. Five years later, the steel reinforced, terra-cotta–clad First National Bank Building replaced the earlier wood-frame structures at the "gore" (junction) of San Pablo Avenue and Broadway.

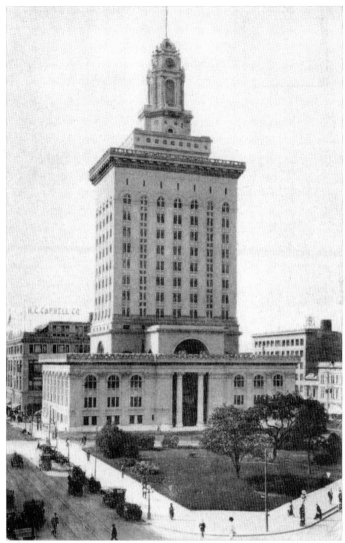

OAKLAND CITY HALL (1911–1914). Elected mayor in 1905, Frank K. Mott challenged citizens to support a bond measure to pay for a new city hall for the new 20th century. A competition was held, and submissions from architectural firms from all over the nation were judged by a committee led by the master architect for the University of California Berkeley campus, John Galen Howard. The New York firm Palmer and Hornbostel was selected. The winning design was a civic monument of granite and terra-cotta, with a three-story podium, a 10-story office tower, and a cupola clock tower rising over 91 feet, the tallest building west of the Mississippi when completed in 1914. It was the nation's first "skyscraper" city hall, combining ceremonial functions and daily city business, and containing courtrooms, an elegant council chamber, a hospital ward, a fire station, and, on the top level beneath the clock, jail cells for city prisoners. To some citizens, the building resembled a tall-tiered white cake. Coincidentally, during construction, the confirmed bachelor Mott got married for the first time, to Gertrude Meyer of San Francisco, promoting news headlines to call the new city hall "Mott's Wedding Cake." Pres. William Howard Taft was on hand to attend the 1911 groundbreaking ceremony. Supervising the on-site construction for the New York Palmer and Hornbostel office was architect John J. Donovan. Donovan would stay on to work on other civic buildings as Oakland's city architect.

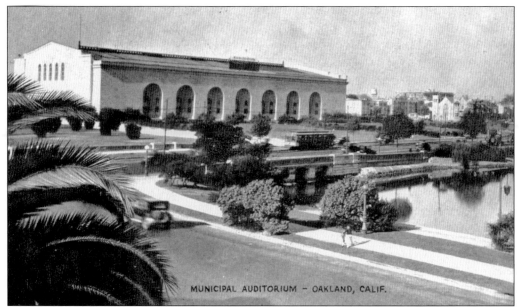

MUNICIPAL AUDITORIUM ON TENTH STREET, OVERLOOKING LAKE MERRITT. As part of his ambitious plan for civic improvement, Mayor Mott directed public funds be spent to erect an auditorium facility at the Twelfth Street end of Lake Merritt, constructed on landfill created from dredging the lake (also paid for with public funds). City architect John J. Donovan oversaw the auditorium project as well. It included an arena, a ballroom, an art gallery, and an concert hall. The auditorium's most distinguishing features were the 60-foot-high north facing niches, with life-size, terra-cotta, bas-relief, allegorical figures created by noted sculptor Alexander Stirling Calder. Illuminated at night, these features were clearly visible from across the lake. In the lower view, the Alameda County Courthouse is on the right.

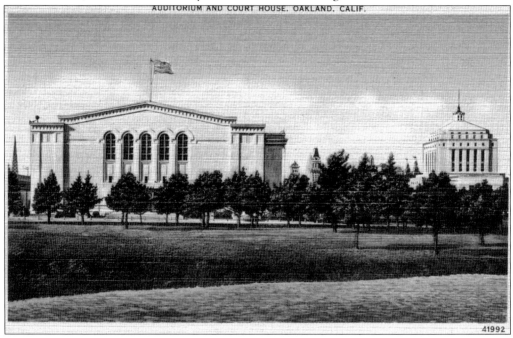

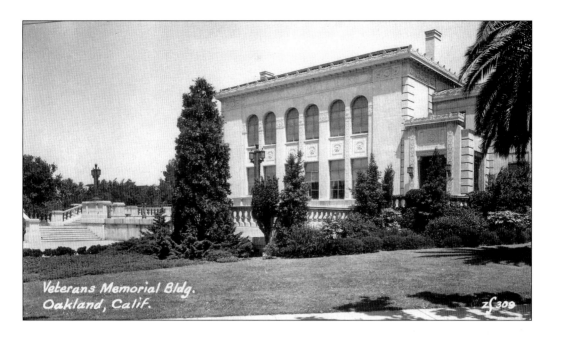

Veterans Memorial Bldg.
Oakland, Calif.

VETERANS BUILDING, ALAMEDA COUNTY. On the north end of the lake, facing Grand Avenue, is the Veterans Building, the first of a dozen such buildings designed for the county by prominent local architect Henry Meyers following the end of the First World War. Meyers held the post of county architect throughout the 1920s; his daughter, Mildred, who studied architecture at the University of California Berkeley, assisted him. Meyers also designed the county's Highland Hospital (see Chapter Six) and the Posey Tube Portals (see Chapter Three).

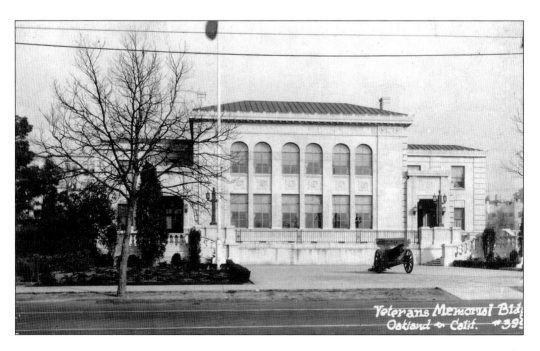

Veterans Memorial Bldg.
Oakland, Calif.

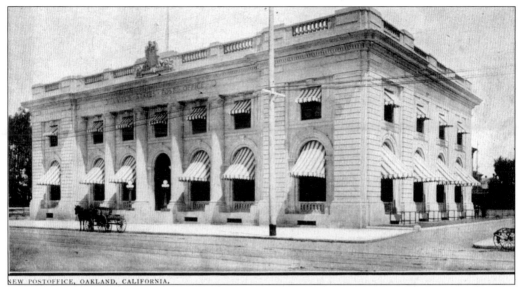

NEW POSTOFFICE, OAKLAND, CALIFORNIA.

DOWNTOWN POST OFFICE, SEVENTEENTH AND BROADWAY. The post office building reflects the "City Beautiful" attitude prevalent throughout America during the early 20th century, which called for public buildings to exhibit a classically conservative style. According to the files, it was the 1893 Chicago World's Fair and its Greco-Roman exhibition pavilions that launched this new urban "ideal."

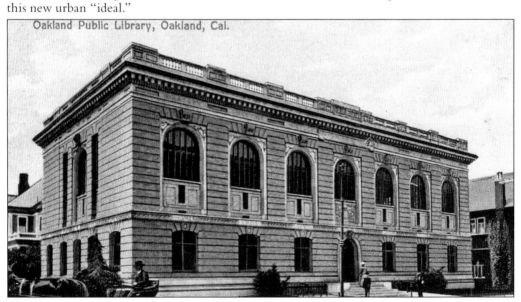

Oakland Public Library, Oakland, Cal.

MAIN LIBRARY, FOURTEENTH AND GROVE STREETS. In 1900, city librarian Charles Greene approached the foundation sponsored by Pittsburgh industrialist Andrew Carnegie for funds to build a new public library for Oakland. Members of a women's organization known as the Ebell Society (see Chapter Five) contributed the corner lot on Fourteenth and Grove Streets. The architectural firm of Bliss and Faville, responsible also for the Hotel Oakland (see Chapter Five) and many other major commissions, produced a classically derived masonry structure, with a flanking twin staircase and a second-level reading room with barrel-vaulted ceiling. The library opened in 1903. Closed for repairs and renovation following the 1989 Loma Prieta earthquake, it now serves as a library and museum dedicated to African-American heritage and culture.

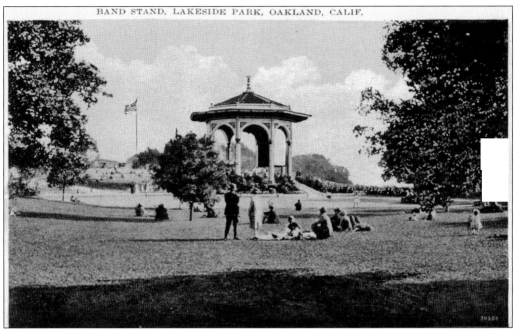

EDOFF BANDSTAND IN LAKESIDE PARK AND CITY HALL. During Mott's administration, a number of improvements took place in the parkland surrounding Lake Merritt, including the construction of this elegant bandstand. Designed by Walter Reed, who was responsible for many of the new lakeside structures, the bandstand was dedicated to James Edoff, a leading early member of the Parks Commission, appointed by Mott to oversee the establishment of parks and recreational facilities throughout the city. At right is a view of city hall from Lake Merritt.

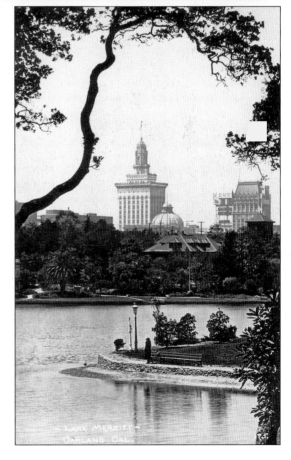

23

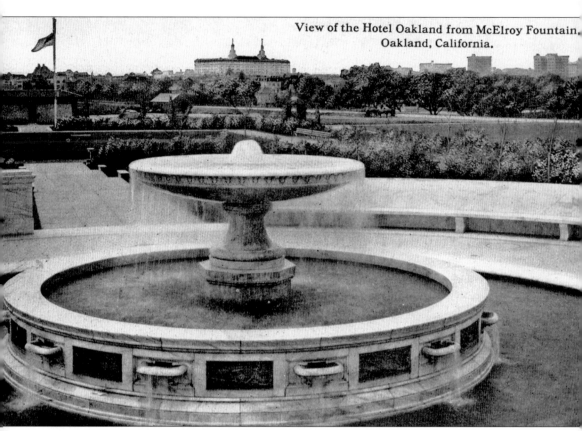

View of the Hotel Oakland from McElroy Fountain, Oakland, California.

MCELROY MEMORIAL FOUNTAIN IN LAKESIDE PARK. John McElroy was Alameda County's district attorney during the time of Mott's city administration (1905–1915). McElroy assisted with the pressing legal issues of the period. He was especially effective during the complex legal battle to help the city regain jurisdiction of the waterfront, which for many years had been under the control of the Southern Pacific Railroad, thanks, in part, to the clever manipulations early on by town founder and Oakland's first mayor, Horace Carpentier. In 1909, McElroy died suddenly at the age of 39 from pneumonia, and his passing was mourned extensively. This elegant marble fountain and basin, with bas-relief panels designed by famed sculpture Douglas Tilden, was erected to McElroy's memory in Lakeside Park, not far from his family home in the Adams Point neighborhood. It was the first piece of public art funded jointly by the city and by private subscriptions.

Wild Ducks at the Embarcadero, Oakland, California. C-145

EL EMBARCADERO PERGOLA. Another civic lake improvement was added in 1918 when Walter Reed designed this curving Italian-Mediterranean flavored pergola structure at the head of the lake's easterly arm. In days gone by, so the story goes, the rancho period Peralta family had a boat landing at the spot to off load supplies and to ship out hides and tallow from their sizable cattle herds.

Watching the Wild Ducks, The Embarcadero, Oakland, California. C-246

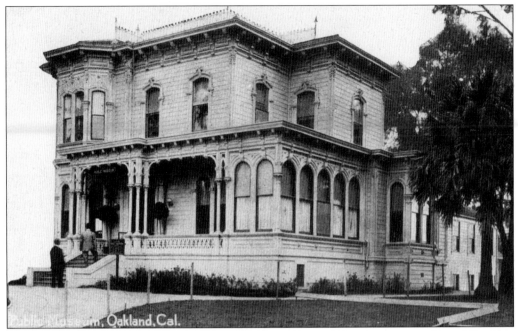

OAKLAND PUBLIC MUSEUM, C. 1910. Mayor Mott directed the city to expend bond funds to acquire this Italianate-style mansion by the lake for use as a public museum. The mansion had formerly been home to a series of owners dating back to 1876, and was originally built by Dr. Samuel Merritt, an Easterner who came to Oakland, acquired building lots, and transformed the inland marsh into the lake we see today.

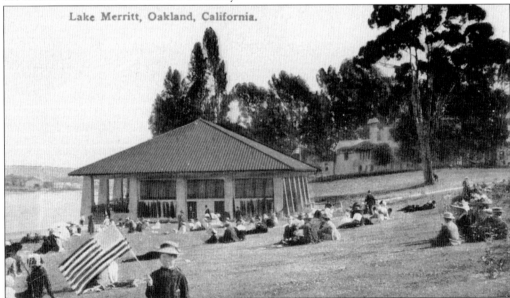

LAKESIDE PUMP HOUSE AND PAVILION. This building, designed by John Galen Howard in 1909, served two functions. It was a pumping station, capable of extracting gallons of lake water in the event of a major fire (a lesson learned from San Francisco's 1906 disaster), and also a public pavilion for viewing regattas and other water-related activities. The museum building is visible in the background.

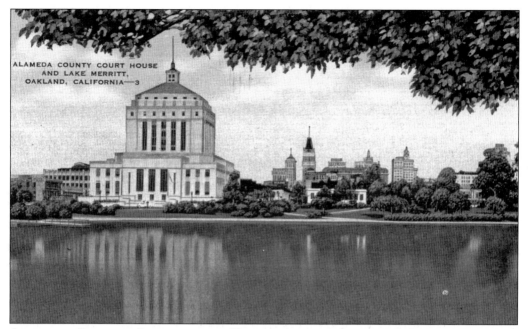

ALAMEDA COUNTY COURT HOUSE
AND LAKE MERRITT,
OAKLAND, CALIFORNIA—3

ALAMEDA COUNTY COURTHOUSE. Close to the pump house and the museum, a new courthouse was erected in the 1930s, part of a plan to establish a lakeside civic center for county and city buildings. The 11-story concrete, granite, and terra-cotta courthouse, classically Moderne in style, takes advantage of its unique lakeside setting, and is an impressive symbol of Alameda County government. It replaced an earlier 19th-century courthouse on Broadway (see Chapter Eight).

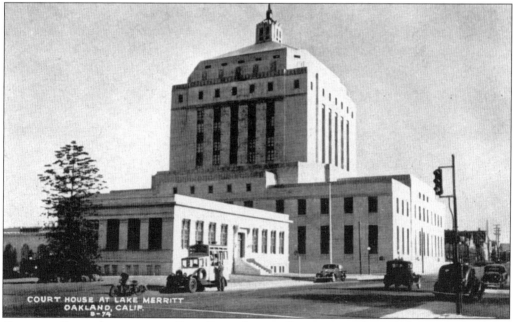

COURT HOUSE AT LAKE MERRITT
OAKLAND, CALIF.
9-74

COUNTY COURTHOUSE AND CITY FIRE ALARM BUILDING. The courthouse is seen here, next to the smaller City Fire Alarm Building, another public safety–oriented structure. Built in 1909, it is utilitarian, yet compatible with its much grander neighbor.

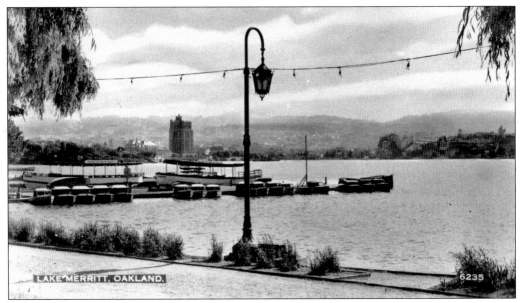

LAKE MERRITT, OAKLAND. 6235

NECKLACE OF LIGHTS, LAKE MERRITT. Dozens of distinctive light pole standards, such as this one, were installed around the lake (a distance of 3.1 miles) as part of the ongoing city beautification campaign. Strung between the poles, spaced 125 feet apart, were strings of electric light bulbs, creating a "necklace" of lights—a magical sight at night. Conceived as a memorial to those Oakland soldiers who died in the First World War, the Necklace of Lights were "blacked out" during World War II. A successful fund-raising campaign in the 1980s brought the string of lights back to life again.

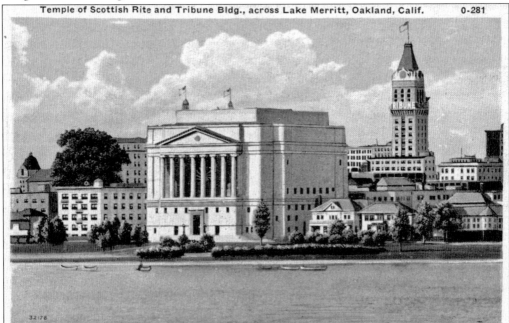

Temple of Scottish Rite and Tribune Bldg., across Lake Merritt, Oakland, Calif. 0-281

32178

SCOTTISH RITE TEMPLE. This imposing five-story, steel-framed, granite-faced edifice on the lake's west side houses the fraternal activities of the Scottish Rite Order. The Oakland Tribune tower is visible in the distance.

Three

DOWNTOWN, TRANSPORTATION, AND INDUSTRY

Oakland experienced a rapid building boom during the 20th century's first 25 years. The hub of downtown activity centered at Broadway and Fourteenth Street where San Pablo and Telegraph Avenues—two thoroughfares that stretched north to neighboring Berkeley and Richmond— also converged.

Impressive high-rises containing banks and commercial offices stood alongside large new department store emporiums. At the waterfront, the newly constituted Port of Oakland took on the challenges of receiving and transporting California's goods and produce, while an extensive network of streetcars connecting to trans-bay ferries also contributed to the region's impressive growth.

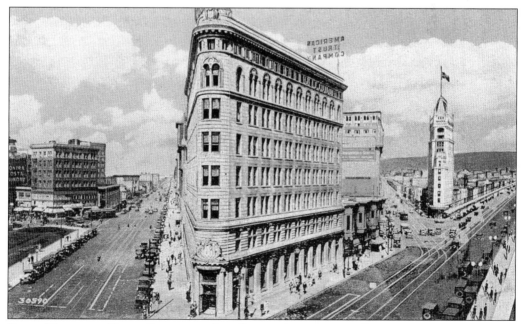

FIRST NATIONAL BANK BUILDING, SAN PABLO AVENUE AND BROADWAY.

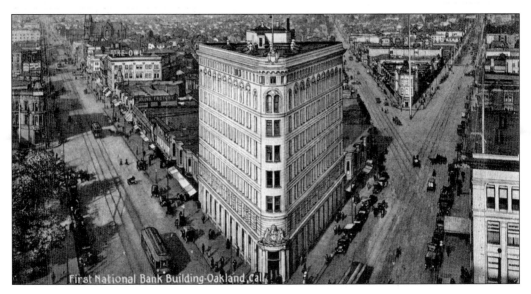

First National Bank Building-Oakland,Cal.

FIRST NATIONAL BANK BUILDING. The above 1908 view of the eight-story, Beaux Arts Classical-style First National Bank is reminiscent of a proud ship's prow coursing down Broadway. It demonstrates how Oakland's downtown radiating street patterns dictated the shape of building construction. Architect Llewellyn Dutton, of Chicago's noted Daniel H. Burnham firm, came to Oakland to open the firm's West Coast office. According to the files, Burnham was responsible for the site plan of the 1893 Chicago World's Fair (often referred to as "The White City"), which featured grand pavilions placed alongside water canals and boulevards. The fair's innovative plan is credited with launching the City Beautiful movement. The postcard below shows the bank in 1915, and another so-called "flatiron" structure, the Federal Realty Company Building is visible in the distance, where Telegraph Avenue merges with Broadway.

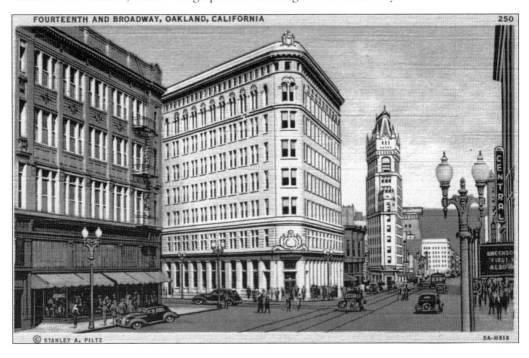

FOURTEENTH AND BROADWAY, OAKLAND, CALIFORNIA 250

© STANLEY A. PILTZ 5A-H918

FEDERAL REALTY BUILDING, C. 1915.
Architect Benjamin Geer McDougall
designed this visually distinctive, 14-story,
Gothic "cathedral of commerce" at the
junction of Telegraph Avenue and Broadway.
The Fox Oakland movie theater is visible
in the distance (see Chapter Four). In the
view below, the building's apex measures
a mere eight and one-half feet. To the left
on Telegraph Avenue stands the 14-story
Latham Building (1925) designed by Maury
I. Diggs, and the Kahn's Department Store,
designed by Charles W. Dickey. They are
products of Oakland's vigorous building
boom following the 1906 earthquake.

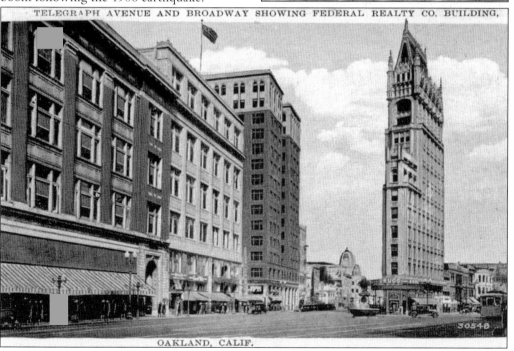

TELEGRAPH AVENUE AND BROADWAY SHOWING FEDERAL REALTY CO. BUILDING,

OAKLAND, CALIF.

31

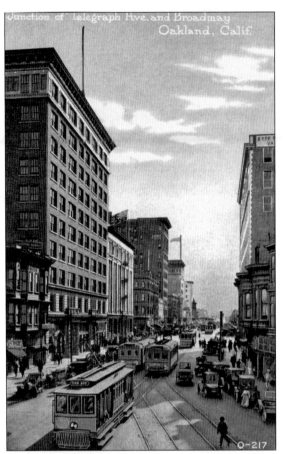

REALTY SYNDICATE BUILDING AND BROADWAY. This *c.* 1912 bustling street scene at Broadway and Telegraph features the 10-story Realty Syndicate Building on the left. This building was the headquarters for the multimillionaire developer Francis Marion Smith and his partner, Frank C. Havens. Their Realty Syndicate bought many hundreds of acres north of downtown in the nearby hills of Berkeley and Oakland, then acquired and consolidated small independent streetcar companies to create a regional public transit system that could transport riders out to the housing tracts. Trans-bay ferries were part of the network as well, so soon commuters were buying lots and building houses in the Syndicate's newly laid out neighborhoods. Oakland's population more than doubled during this period, from 66,000 in 1900 to 150,000 in 1920. Below, in another view of Broadway and Telegraph Avenue, looking south, the Realty Syndicate Building is on the left, Kahn's Department Store on the right, and the elegant cast-iron Latham Memorial Fountain in the center.

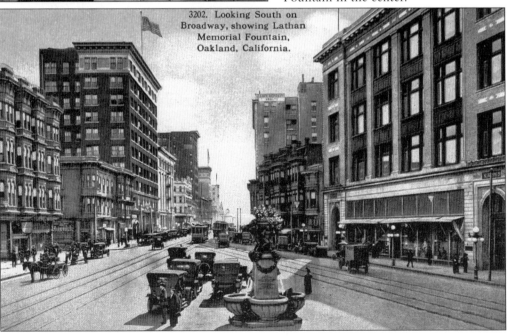

FINANCIAL CENTER BUILDING, FOURTEENTH AND FRANKLIN STREETS.
This was built in 1929 by the firm Reed and Corlett for the Franklin Land Company, a development group led by merchandiser H. C. Capwell. The 15-story high-rise features art deco accents and an elegant interior lobby.

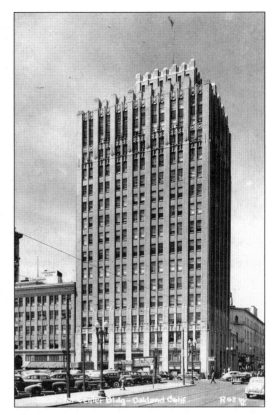

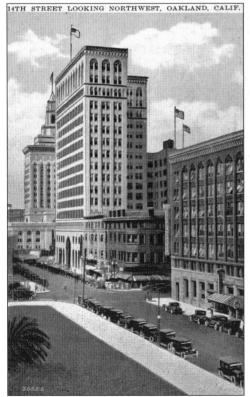

14TH STREET LOOKING NORTHWEST, OAKLAND, CALIF.

FOURTEENTH STREET LOOKING WEST, CENTRAL BANK BUILDING. George Kelham designed this banking headquarters in 1925, and it reflects a previously preferred architectural style with more Renaissance/ Romanesque influences. City hall is visible west of Broadway.

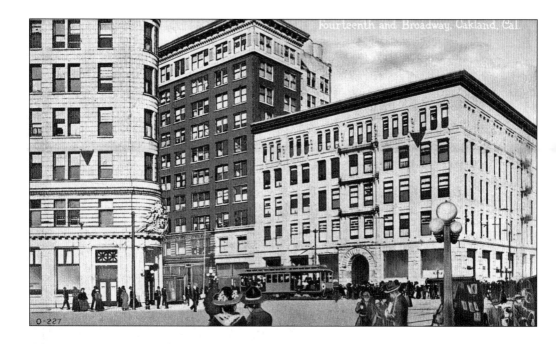

BROADWAY AND FOURTEENTH STREET. The view above shows of downtown's most important intersection, Broadway and Fourteenth Street. Buildings visible in this view are the First National Bank, the Realty Syndicate Building, and the earlier version of the Central Bank Building, which was five stories tall and built in 1893. It suffered damage in the 1906 earthquake and was replaced by the 1925 high-rise seen on page 33. Below is a closer view of busy Fourteenth Street in the 1920s, looking west.

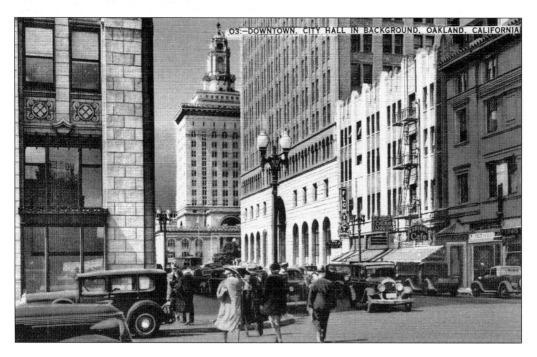

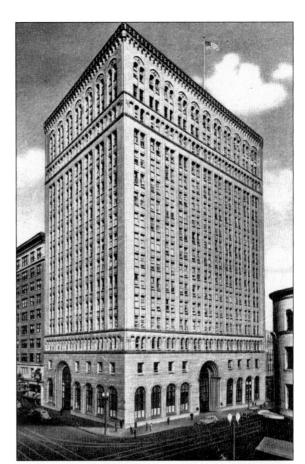

CENTRAL BANK BUILDING. At right is a full-length view of the Central Bank Building. Architect George Kelham received his training at the Ecole des Beaux Arts in Paris. He also designed the elegant Palace Hotel on Market Street in San Francisco. Below is the bank's marbled grand banking hall.

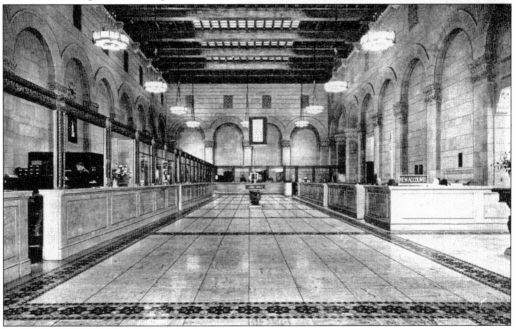

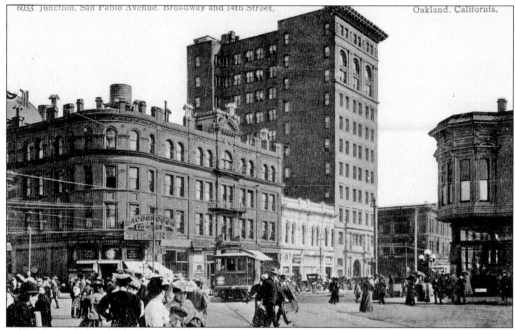

MacDonough Theater, Fourteenth Street and Broadway, c. 1910. Starting in the 1890s, the landmark MacDonough Theater on the southeast corner of Fourteenth Street and Broadway offered appearances by the likes of stage stars Ethel Barrymore and Enrique Caruso, who performed for the "carriage trade." After World War I, the MacDonough was remodeled as a motion picture theater, and the most popular pictures of the day premiered there to appreciative crowds. It changed hands several times during the 1930s and closed for good in 1945.

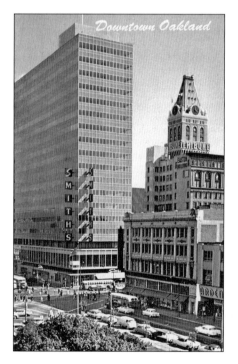

Smith Building, c. 1960. In 1956, an 18-story, steel-frame, international-style high-rise replaced the long-shuttered MacDonough Theater. Designed by the firm Stone, Mulloy, Marraccini, and Patterson for the First Western Savings Company and Smith Brothers Men's Clothiers, the new building interjected a modern, mid-20th-century feel to the Fourteenth and Broadway area when it opened.

36

TRIBUNE BUILDING, C. 1917. When former six-term congressman Joseph P. Knowland bought the *Oakland Tribune*, he moved operations into the former Breuner's Furnishings Store on the corner of Thirteenth and Franklin Streets. Plans called for an adjoining 21-story tower structure, which would eventually be completed in 1922. In this view, Mr. Knowland announces his intentions, with the four-part *Tribune* neon sign and clock faces suspended above, awaiting completion of the soon-to-be-famous tower.

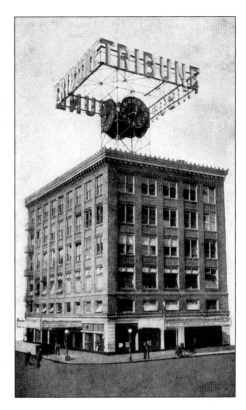

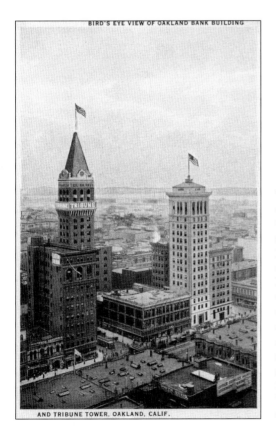

BIRD'S EYE VIEW OF OAKLAND BANK BUILDING

AND TRIBUNE TOWER, OAKLAND, CALIF.

TRIBUNE TOWER AND OAKLAND BANK OF SAVINGS BUILDING. In this 1920s view, the tower, with its hipped chateau-style roof and illuminated *Tribune* sign, is a unique landmark on the downtown skyline. The architect was Edward T. Foulkes. Nearby on Broadway and Twelfth Street is the 18-story Oakland Bank of Savings tower by Reed and Corlett, an adjoining addition to its shorter neighbor on the right (built in 1908 and designed by Charles W. Dickey). The two side-by-side commercial Beaux Arts–style structures are yet another in a series, housing financial institutions clustered between Tenth and Sixteenth Streets that were erected during the post-earthquake boom.

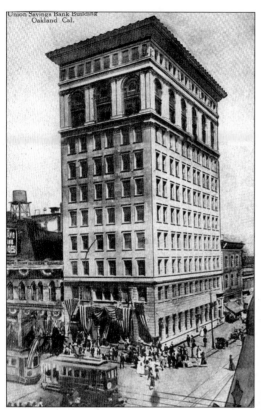

UNION SAVINGS BANK, C. 1903. The construction date for this 11-story Beaux Arts–style "skyscraper" predates the 1906 earthquake. It was Oakland's first high-rise, modern, steel-frame structure and was designed by locally prominent architect J. Walter Mathews.

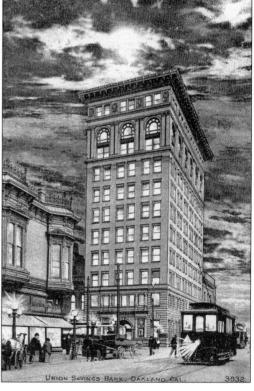

UNION SAVINGS BANK, BROADWAY AND THIRTEENTH STREET. It appears that many postcard views of the Union Savings Bank were produced, perhaps to demonstrate Oakland's emerging prominence as a major metropolitan city. This is a nighttime view; note the streetcar and electric streetlamps, further evidence of Oakland's coming of age in the new 20th century.

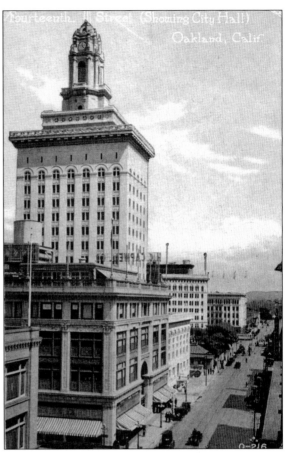

H. C. Capwell Department Store. The H. C. Capwell Department Store opened in 1912 on the corner of Fourteenth and Clay Streets while its next door neighbor, city hall, was still under construction. Merchandiser Harrison C. Capwell had previously operated a smaller shop on Ninth and Washington Streets, then moved "uptown" to take advantage of being close to the impressive new city hall building. The store's corner location allowed for two grand entrances, as shown in the illustration below. Its locally prominent architect, Charles W. Dickey, also designed the Claremont Hotel (see Chapter Five).

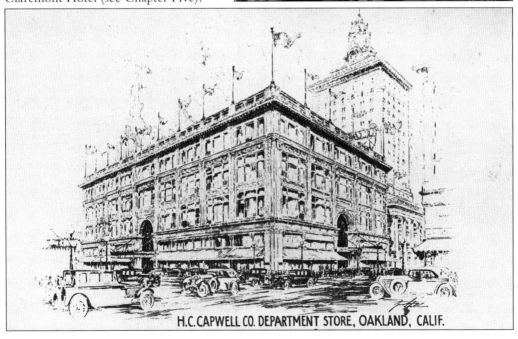

H.C. CAPWELL CO. DEPARTMENT STORE, OAKLAND, CALIF.

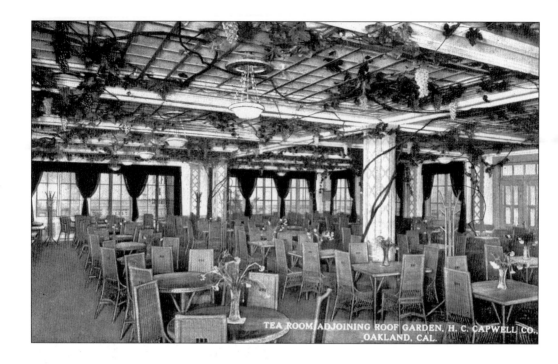

TEA ROOM ADJOINING ROOF GARDEN. H. C. CAPWELL CO., OAKLAND, CAL.

H. C. CAPWELL DEPARTMENT STORE. The new store featured many amenities to attract primarily lady shoppers, who could catch convenient streetcars downtown to shop and lunch with friends. A tearoom, pictured above, provided an elegant meal. The roof garden, pictured below, offered a view of the Berkeley hills.

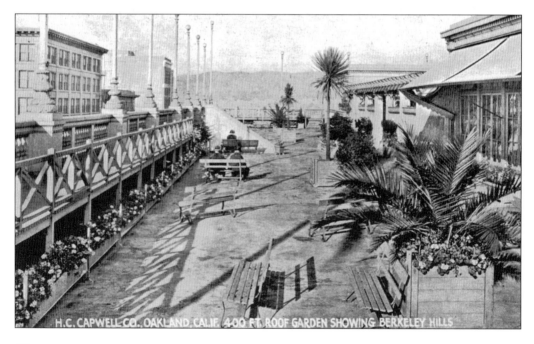

H.C. CAPWELL CO., OAKLAND, CALIF. 400 FT. ROOF GARDEN SHOWING BERKELEY HILLS

Roof garden, H. C. Capwell Department Store. In 1929, Capwell would decide to move his store yet again, even further uptown, to Broadway and Twentieth Street. This decision would mark a shift further north for shopping and entertainment opportunities, a reflection of the increasing numbers of more affluent families buying homes in districts such as Rockridge, Piedmont, and Montclair. More and more, shoppers would turn to private automobiles, rather than public streetcars, for their trips downtown.

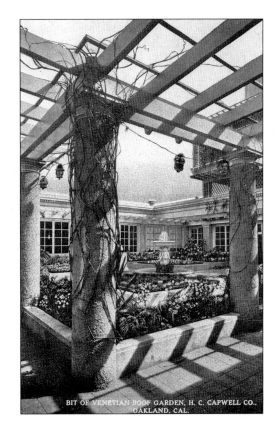

BIT OF VENETIAN ROOF GARDEN, H. C. CAPWELL CO., OAKLAND, CAL.

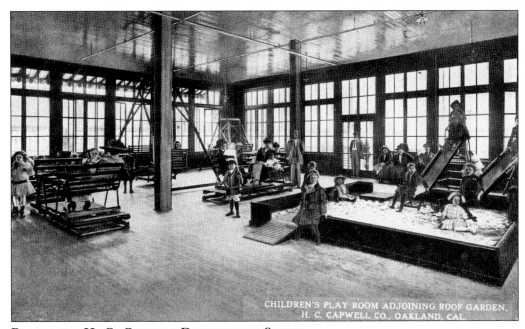

CHILDREN'S PLAY ROOM ADJOINING ROOF GARDEN, H. C. CAPWELL CO., OAKLAND, CAL.

Playroom, H. C. Capwell Department Store.

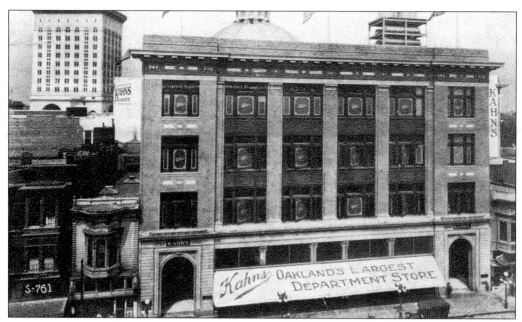

KAHN DEPARTMENT STORE. Architect Charles W. Dickey also designed a store for mercantile pioneer Israel Kahn, who was originally from New York. Kahn moved from a much smaller shop he operated on Washington Street to the new location across the plaza from city hall. The new Kahn store, modeled on Parisian-style establishments with many "departments" under one roof, featured a light-filled, four-story atrium with a magnificent elliptical dome overhead, where luxury goods could be displayed to their utmost advantage. The new store (with a 1923 addition) occupied space with frontages on Broadway, San Pablo Avenue, and Sixteenth Streets.

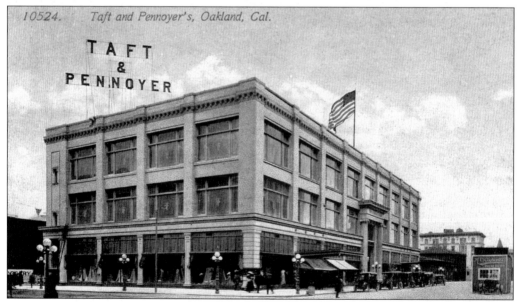

TAFT AND PENNOYER DEPARTMENT STORE. This was yet another shopping destination, located across Clay Street from Capwell's on another highly visible corner (at Fourteenth Street). Later Capwell's and Taft and Pennoyer would merge.

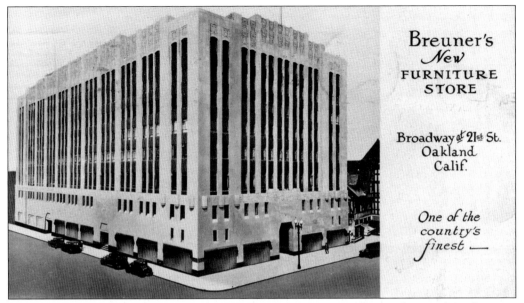

Breuner's
New
FURNITURE
STORE

Broadway *&* 21ˢᵗ St.
Oakland
Calif.

*One of the
country's
finest —*

BREUNER'S FURNISHINGS STORE. John C. Breuner was a German-born cabinetmaker who came to California during the gold rush. In 1906, he and his sons relocated to Oakland, where they opened a furniture business and showroom on Thirteenth Street. After selling the building to the *Oakland Tribune*, the Breuner's relocated to the Broadway and Twentieth Street area, following H. C. Capwell. His even bigger store opened in 1929, shortly before the stock market crash.

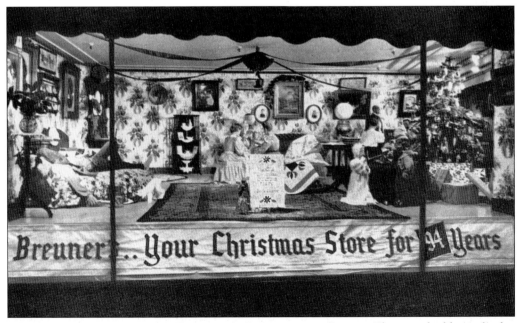

HOLIDAY WINDOW DISPLAY, BREUNER'S FURNISHINGS STORE. The store had large display windows, designed to attract the eye of shoppers who were now more frequently coming downtown by automobile instead of streetcar. Holiday windows with miniature decorated "rooms" were a popular annual tradition for many seasons.

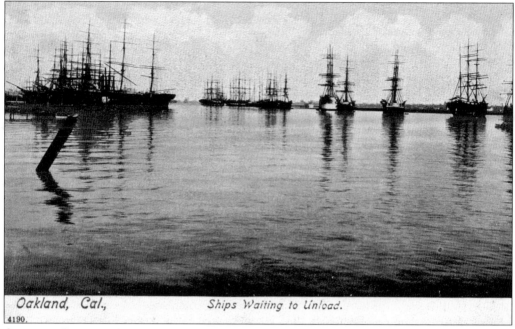

Oakland, Cal., Ships Waiting to Unload.
4190.

ALASKAN PACKERS ASSOCIATION SAILING VESSELS MOORED IN THE OAKLAND/ALAMEDA ESTUARY. The association was incorporated in 1893 to fish for salmon off the Alaskan coastline. By 1902, 23 cannery companies belonged to the association, which also owned a fleet of ships. Seen here during the winter season, the ships moored in the protected waters of the estuary, undergoing repairs in readiness for the next summer season.

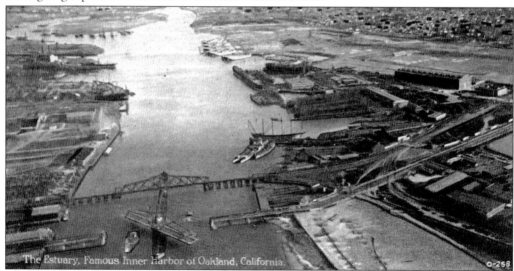

The Estuary, Famous Inner Harbor of Oakland, California. O-256

EARLY-20TH-CENTURY VIEW OF THE OAKLAND/ALAMEDA ESTUARY. In the 1920s, Oakland's waterfront really began to come into its own. Prior to that time, issues over how the harbor would be controlled and managed were tied up in complicated and costly litigation, stemming from decisions early on by town founders that allowed the railroad company to claim possession. Mayor Mott is credited with finally breaking this long-standing impasse and regaining control of the port. In this view looking east, the Webster Street drawbridge is making way for watercraft to pass.

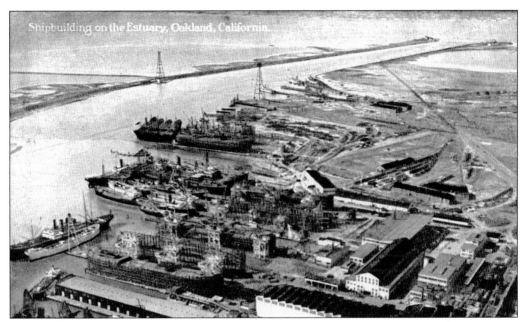

OAKLAND/ALAMEDA ESTUARY, LOOKING WEST. In 1927, during Mayor Davie's administration, an independent board of five port commissioners was appointed to oversee the newly constituted Port of Oakland operations. Named to the commission was former California governor George Pardee and department store owner H. C. Capwell. Increased maritime activities at the port, including shipbuilding, pictured here, were affected by the opening of the Panama Canal and the subsequent increase in Pacific trade.

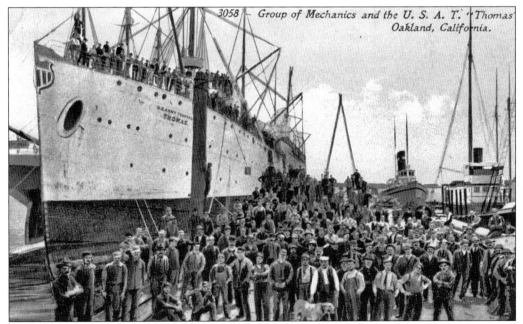

DOCKWORKERS, PORT OF OAKLAND. Opportunities for well paying jobs at the port attracted workers from around the United States, as Oakland's facilities became one of the busiest on the West Coast.

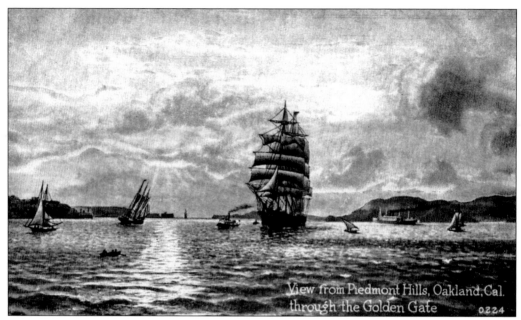

ALASKAN PACKER SCHOONER UNDER SAIL. During the years when the schooners arrived or departed through the Golden Gate every season, sailing ships were a memorable sight on the San Francisco Bay.

VESSEL DOCKED AT PORT OF OAKLAND PIER. In 1928, the Port of Oakland became an official port of entry to the United States, eliminating the necessity of calling first at the Port of San Francisco's customs office. This change opened the way for more foreign trade. That year, more than 3,000 vessels, carrying two million tons of cargo, berthed at Oakland piers.

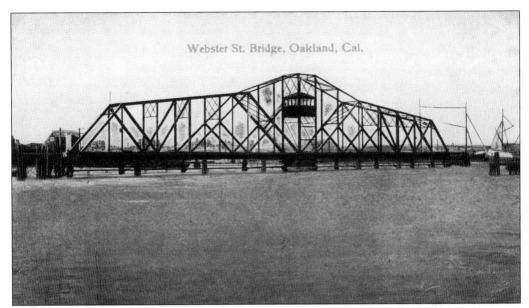

Webster St. Bridge, Oakland, Cal.

WEBSTER STREET BRIDGE. The Webster Street Bridge connected Oakland to the town of Alameda, which was located across the estuary. The bridge would later be replaced by an underground tunnel in 1928, a harbor improvement that was intended to facilitate maritime traffic (see page 60).

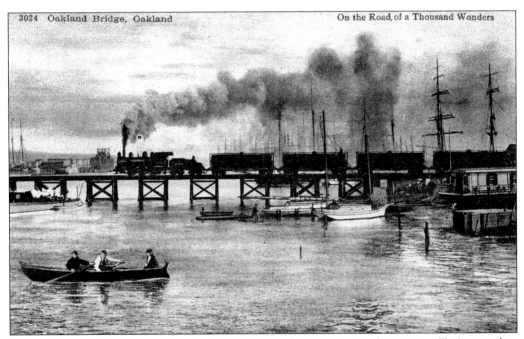

3034 Oakland Bridge, Oakland On the Road of a Thousand Wonders

STEAM TRAIN CROSSING THE ESTUARY FROM OAKLAND TO ALAMEDA. Train travelers enjoyed selecting postcard views and sending them home to family and friends. Promotional cards dubbed the Pacific Coast journey, including the trip across the estuary, "on the road of a thousand wonders."

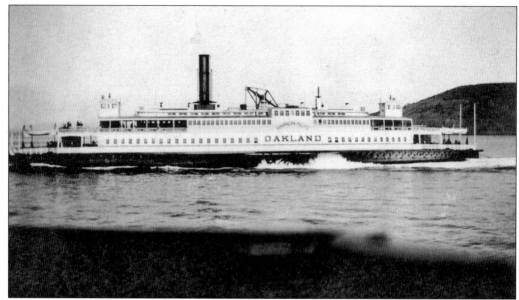

SOUTHERN PACIFIC FERRYBOAT *OAKLAND.* In 1875, the Central Pacific Railroad (later Southern Pacific) purchased and refurbished the double-end ferryboat called the *Oakland.* According to the files, she carried more passengers through the estuary and across to San Francisco than any other ferry transport. Her career came to an end in 1940 when, tied up at the southern Alameda shore, her hull caught fire and she sank.

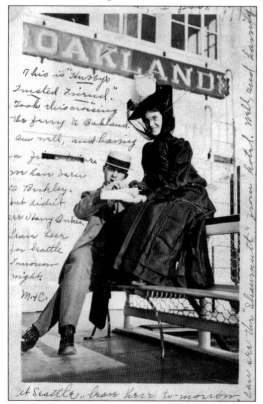

SOUTHERN PACIFIC FERRYBOAT *OAKLAND.* Here a pair of passengers shares a crossing on the ferryboat *Oakland.* Judging by the young lady's hat, this could have been in the late 1890s or early 1900s.

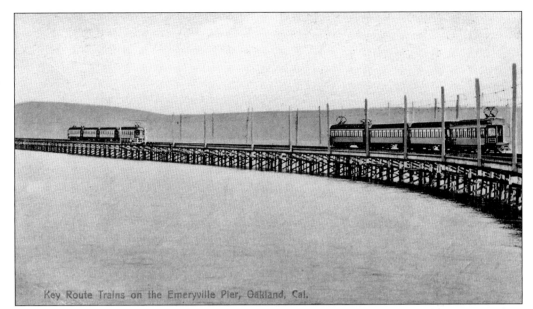

Key Route Trains on the Emeryville Pier, Oakland, Cal.

KEY ROUTE TRAINS OVER WATER. The official name for the Realty Syndicate's transit line of electric trains was the San Francisco, Oakland, and San Jose Railway, but everyone was soon calling it the "Key Route," because the company's three-mile pier out to the ferry terminal reminded people of the long shaft of an old-fashioned house key, with the ferry slips representing the key's "teeth." The nickname stuck.

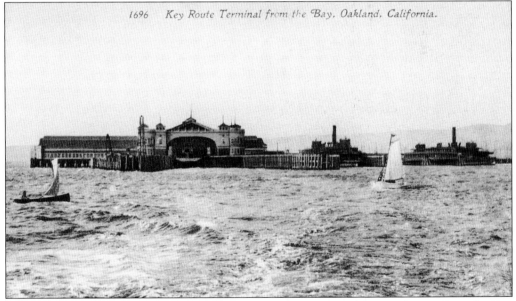

1696 Key Route Terminal from the Bay, Oakland, California.

KEY ROUTE FERRY TERMINAL. The ferry terminal was located three miles out from the East Bay Shore, almost to Yerba Buena Island. During the system's heyday in the mid-1930s, prior to the completion of the bay bridge, there were 43 ferries operating with nearly eight million riders crossing annually.

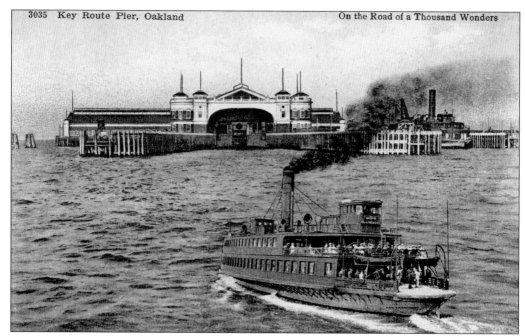

FERRY APPROACHES KEY ROUTE TERMINAL. This is another promotional card for the "on the road of a thousand wonders" series. Travel time from the East Bay to the "City" was 28 minutes.

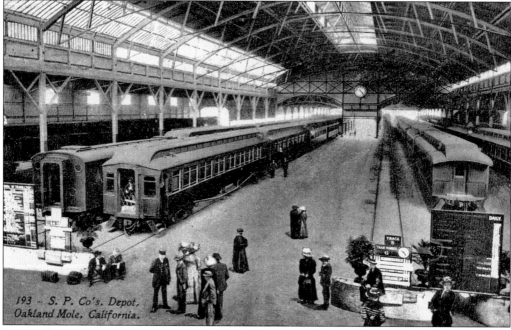

193 – S. P. Co's. Depot, Oakland Mole, California.

INSIDE SOUTHERN PACIFIC'S DEPOT, "THE OAKLAND MOLE." A competitor of the Key Route trains and ferries was the Southern Pacific fleet of trains and boats. Here is a view of Southern Pacific's *Oakland Mole* off the end of the Seventh Street train line. In 1930, Southern Pacific's ridership was said to be close to 20 million passengers.

50

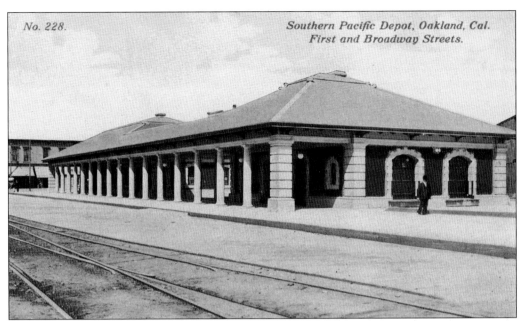

SOUTHERN PACIFIC DEPOT, FIRST STREET. This depot was demolished in the 1950s to make way for Jack London Square development. A motor inn now occupies the site (see Chapter 7.)

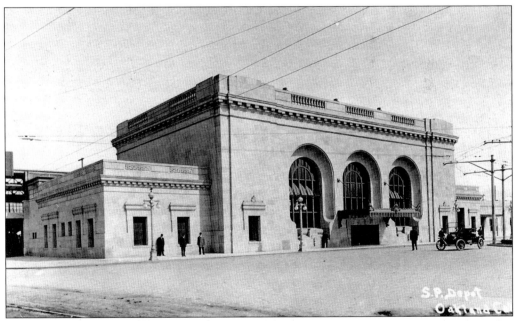

INTERMODAL TRAIN STATION, SIXTEENTH AND WOOD STREETS. Constructed in 1912 during the Mott administration, the grand interurban station at Sixteenth and Wood Streets was designed by nationally prominent architect Jarvis Hunt, known for train stations he built elsewhere for Southern Pacific. An elevated track ran behind the station so passenger commuter lines could be diverted from the main surface lines, where slower moving freight trains ran.

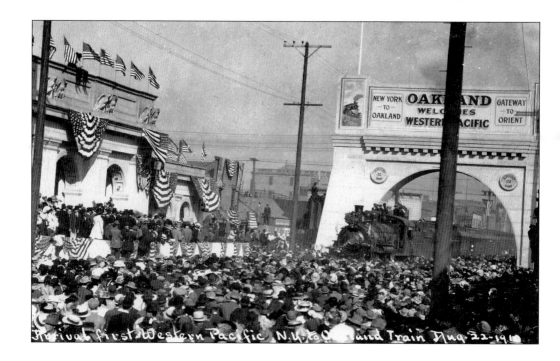

Arrival first Western Pacific N.Y. to Oakland Train Aug. 22-1910

WESTERN PACIFIC TRAIN STATION. The Western Pacific transcontinental railroad line opened a station at Third and Washington Streets in 1910, its western terminus. The view above records the opening celebration. Below, a train approaches the station.

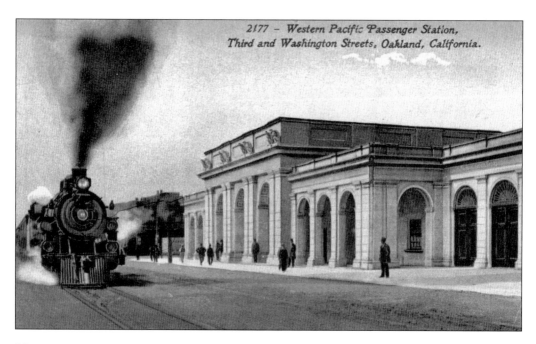

2177 – Western Pacific Passenger Station,
Third and Washington Streets, Oakland, California.

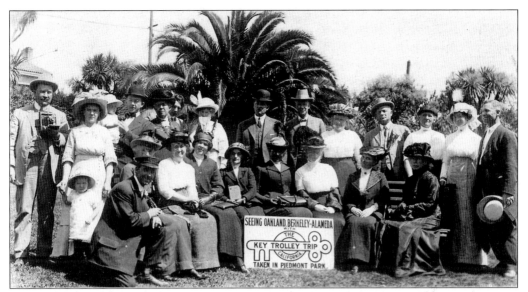

POSING AT THE KEY ROUTE SYSTEM PIEDMONT STATION. Judging by the dress, this group could be posing in the 1910s or early 1920s. Note the key symbol logo on the banner.

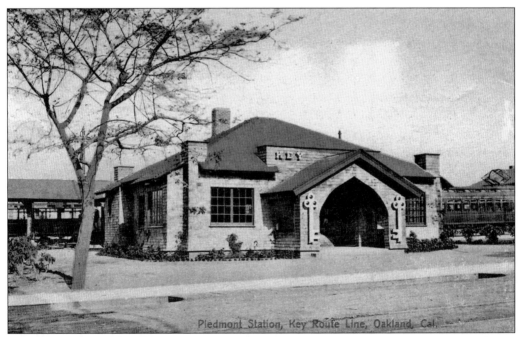

KEY ROUTE SYSTEM, PIEDMONT STATION. This neighborhood station was located on Piedmont and Fortieth Streets. The Key System was eventually acquired by National City Lines Company after World War II. Under new ownership, the streetcars were done away with, the tracks were dismantled, and buses operated in their place, following, for the most part, the same routes. It was the end of an era.

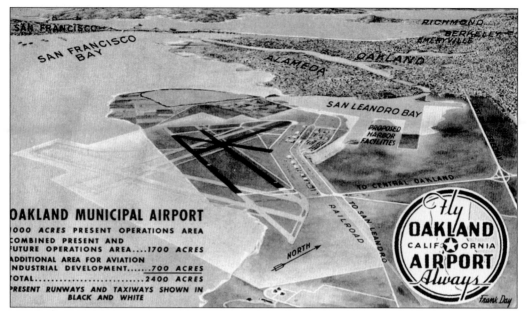

OAKLAND MUNICIPAL AIRFIELD. In 1926, the city acquired a 680-acre tract of Bay Farm Island for $625,000, and responsibility for developing an airfield was transferred to the newly established Port of Oakland.

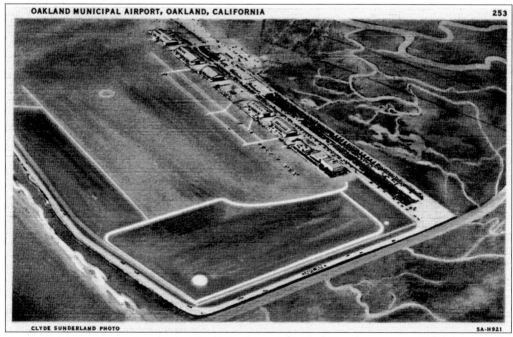

OAKLAND MUNICIPAL AIRFIELD, NORTH FIELD. Dedicated on May 21, 1927, by none other than Charles Lindbergh, Oakland's airfield became one of the very first commercial airport facilities in the country. Later that year, it was designated the western terminus for transcontinental airmail. According to the files, the airport on Bay Farm Island was the point of departure for Amelia Earhart's ill-fated, round-the-world flight in 1937, which ended with her disappearance over the Pacific.

FLYING OVER THE SAN FRANCISCO OAKLAND BAY BRIDGE. By the time the bay bridge was completed in 1939, air traffic in and out of Oakland was frequent.

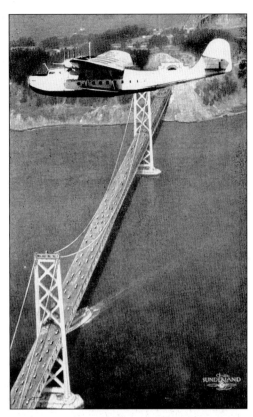

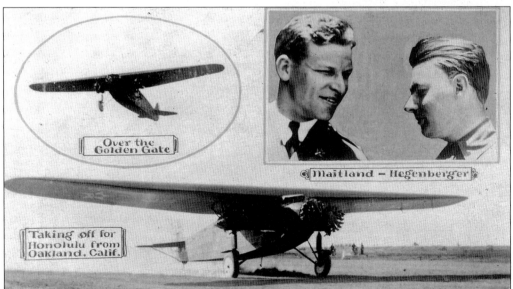

Over the Golden Gate

Maitland – Hegenberger

Taking off for Honolulu from Oakland, Calif.

ARMY LIEUTENANTS LESTER J. MAITLAND AND ALBERT F. HEGENBURGER'S NONSTOP PACIFIC FLIGHT, JUNE 28, 1927. Oakland's runway at 7,020 feet—unusually long for the time—was selected for this historic flight because their fuel-heavy plane needed it for liftoff. Thousands watched the pair, in their Fokker C-2 transport, set out on the 25-hour, 50-minute journey.

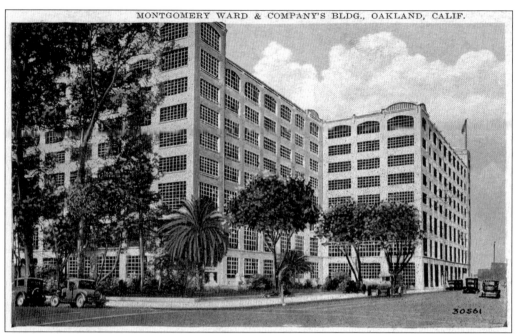

MONTGOMERY WARD WAREHOUSE. This eight-story warehouse facility, designed by company architect W. H. McCaully, opened in 1923 on Twenty-ninth Avenue and East Fourteenth Street (one of the region's major east-west arteries). At one million square feet, it was Montgomery Ward's primary distribution center for the West Coast.

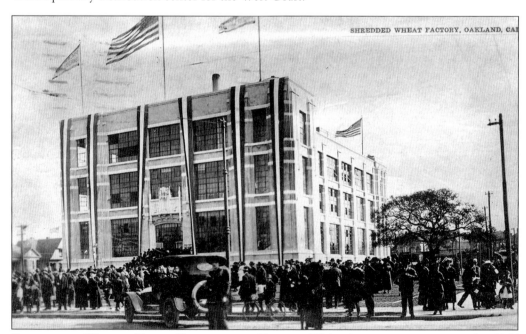

SHREDDED WHEAT FACTORY, OAKLAND, CAI

SHREDDED WHEAT FOOD PROCESSING PLANT. This view commemorates the 1917 grand opening of this facility on Union Street in West Oakland, close to nearby rail lines. The breakfast cereal industry was beginning to grow in popularity as American families' food habits were changing.

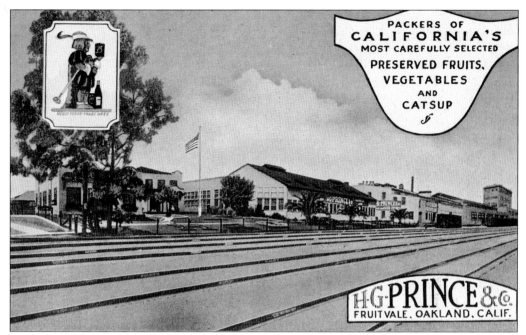

H. G. Prince and Company, Fruit Packing Plant. Fruit canneries were an important industry for Oakland and Alameda County during the years of Mott and Davie's administrations. This is a view of the H. G. Prince and Company fruit packing plant in the Fruitvale district east of Lake Merritt.

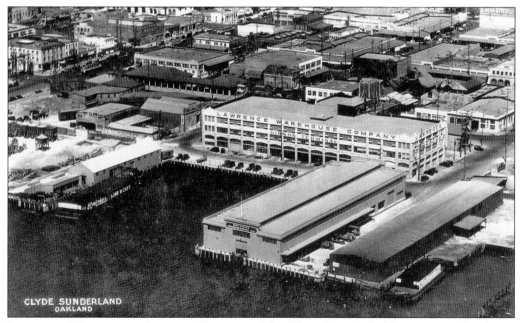

Lawrence Warehouse Company Building. The Gibson Terminal of the Lawrence Warehouse Company was built in 1927 and was located at the foot of Webster Street on the waterfront. Starting in 1961, for the next two decades, the Port of Oakland's administrative offices were located in the building following its conversion from storage warehouse to commercial structure.

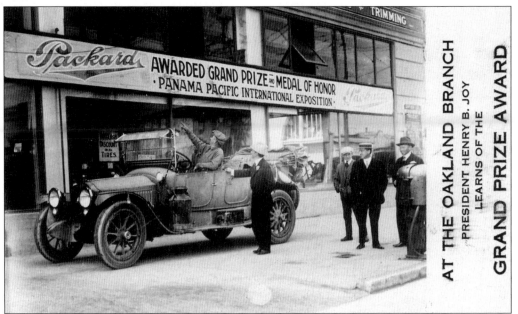

PACKARD AUTOMOBILE SHOWROOM, BROADWAY AND TWENTY-FOURTH STREET. In the 1920s, a 20-block stretch of Broadway north of Grand, became known as "auto row" for the number of automobile dealerships, car mechanics, tire stores, and other related businesses that established themselves along that stretch.

DURANT MOTOR COMPANY MANUFACTURING PLANT, EAST FOURTEENTH STREET. In the early 1920s, Mayor Davie eagerly encouraged William C. Durant, an early founder of General Motors, to come out to California, where the weather was mild, and open an assembly plant in East Oakland. Later, a Chevrolet plant opened, attracting various automotive parts manufacturers to establish themselves as well, thus earning Oakland the nickname "Detroit of the West."

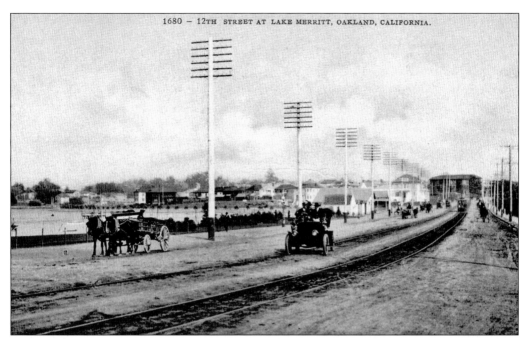

TWELFTH STREET AT LAKE MERRITT, LOOKING EAST. In this turn-of-the-20th-century view of Twelfth Street, three modes of transportation can be seen: horse-drawn cart, early automobile, and rail lines for the streetcar. Electric street poles are also visible.

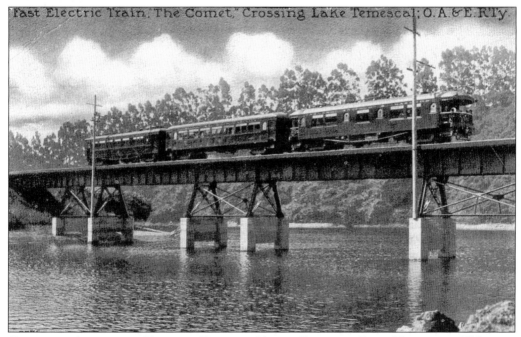

OAKLAND, ANTIOCH & EASTERN RAILWAY TRAIN CROSSING LAKE TEMESCAL. This was a commuter line with connections as far as Sacramento. In the mid-1930s, Lake Temescal would be transformed into a public recreational park, as part of the newly created East Bay Regional Park District system (see Chapter Four).

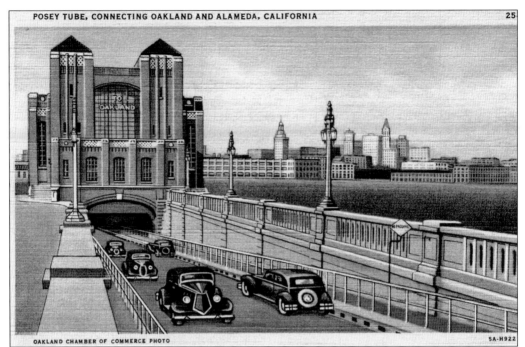

OAKLAND CHAMBER OF COMMERCE PHOTO 5A-H922

POSEY TUNNEL CONNECTING OAKLAND AND ALAMEDA. In 1928, voters approved a $4.5 million bond measure to construct an underwater tunnel connecting Oakland to Alameda, eliminating the need for surface bridges that were hampering estuary navigation. Locally prominent architect Henry Meyers designed the gateway portals at the tunnel's entrances on both the Oakland and the Alameda side. George Posey was the county surveyor who worked on the project, for whom the portals were named.

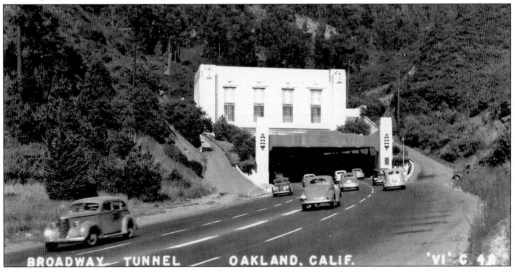

BROADWAY TUNNEL CONNECTING OAKLAND AND ORINDA. The travel time between Oakland/Berkeley and neighboring Contra Costa County went from two–plus hours to 35 minutes, once the two 3,600-foot-long, concrete-lined bores through the coastal hills were completed in 1937. A third bore was added in the 1960s (by then 54,000 cars were passing through daily). At that time, the tunnel was rededicated in honor of county supervisor Thomas Caldecott.

Four

PARKS AND RECREATION

During Mayor John Davie's four terms in office beginning in 1915, postcard views of Oakland's many parks, public squares, and recreational amenities no doubt helped convince visitors to become new residents. Postcards advertised the East Bay's balmy, Mediterranean climate and the new attractive home sites in neighborhoods close to convenient public transit. Mayor Davie, who never went anywhere without a red carnation boutonniere, was the city's biggest booster. While Lake Merritt remained the most centrally located and accessible public park for most Oaklanders, the establishment of parks in the hills, including Joaquin Miller Park and Temescal Park, greatly increased ways for citizens to enjoy the outdoors.

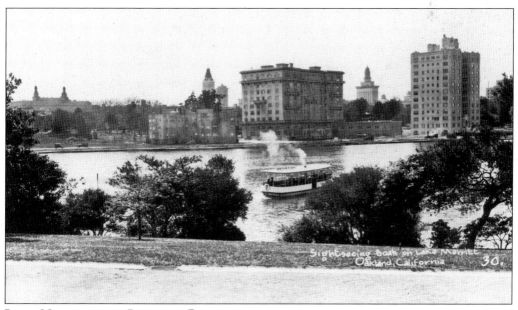

LAKE MERRITT AND LAKESIDE PARK.

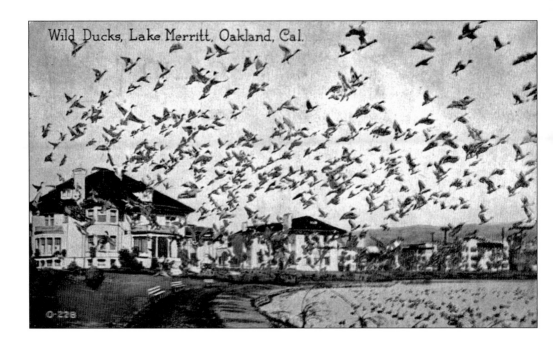

Wild Ducks, Lake Merritt, Oakland, Cal.

O-228

BIRD REFUGE, LAKE MERRITT. The lake area was officially designated a bird refuge in 1870 by California's governor. It is believed to be the first such designation in the nation. Previously, the then marshy slough habitat attracted bird hunters from San Francisco. After Samuel Merritt succeeded in damming the slough at Twelfth Street, thereby creating a lake, it became more attractive for home sites. Recreational hunting would henceforth become off limits.

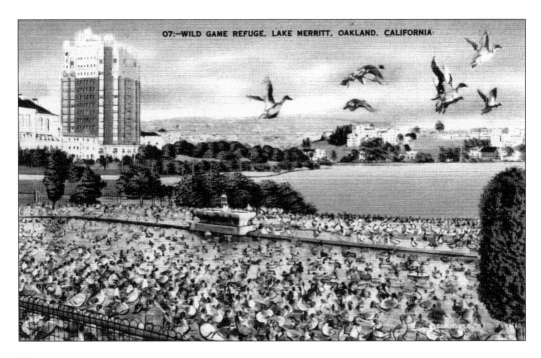

07:—WILD GAME REFUGE. LAKE MERRITT. OAKLAND. CALIFORNIA.

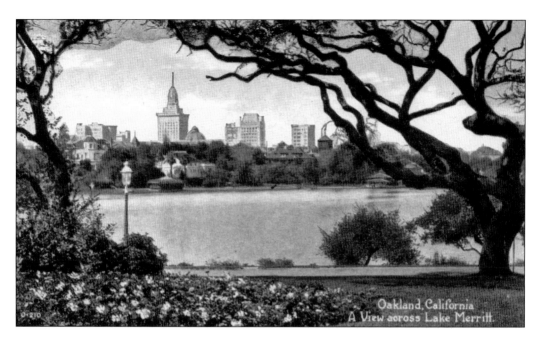

LAKE MERRITT. Above, city hall and other downtown buildings are visible in the distance, from Lakeside Park, looking west. The view below shows a private dock landing on the lake. During the city's early years, substantial homes with private dock landings and gardens stretching to the water's edge began to appear, transforming the lakeside into a desirable residential area.

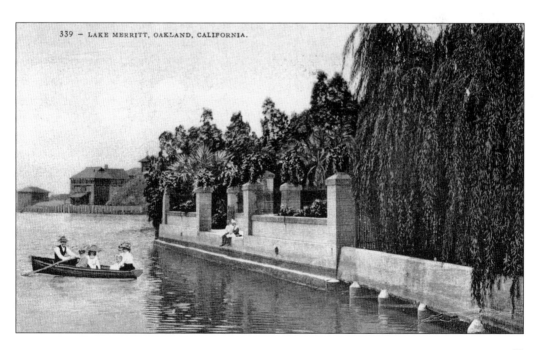

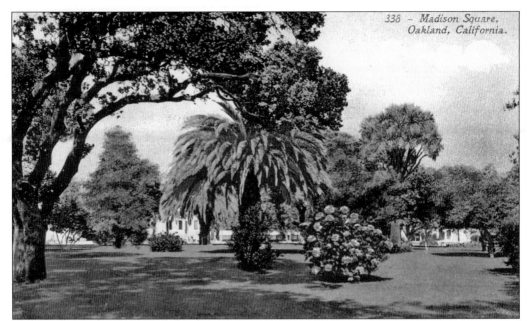

338 – Madison Square,
Oakland, California.

MADISON SQUARE PARK. Madison Square Park was one of the original public squares established when the town was first planned in the 1860s. Other public squares include Jefferson, Lincoln, and Lafayette (see Chapter Six).

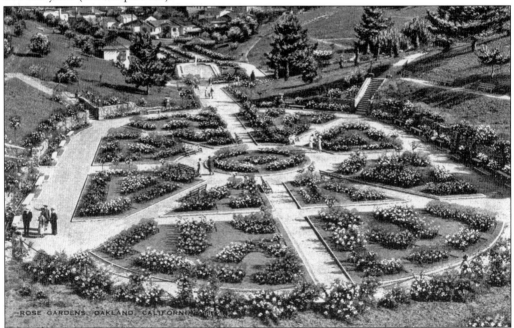

ROSE GARDENS, OAKLAND, CALIFORNIA

MUNICIPAL ROSE GARDEN. Mayor Mott's plan to use public funds to acquire more park land, led to the city purchasing eight acres of surplus Key Route right-of-way property along an arroyo, near Grand Avenue, in 1912. Some years later, the undeveloped park parcel was transformed into an Italianate municipal rose garden with the sponsorship of community garden clubs. Its name became the Morcom Rose Garden, for Mayor Frank Morcom (John Davie's successor), in 1931.

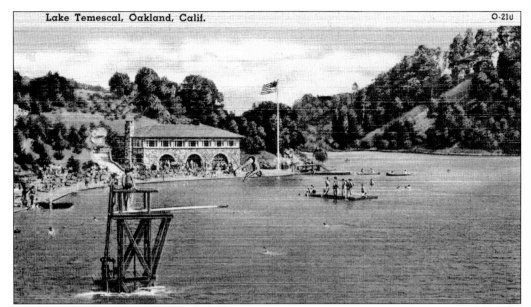

LAKE TEMESCAL RECREATION AREA. In the 1860s, Temescal Creek (from the American Indian word for "sweat lodge") was dammed in order to create a reservoir. A self-taught hydraulic engineer named Anthony Chabot was the creator of what came to be known as Lake Temescal. In the 1930s, Lake Temescal was set aside for recreational uses, becoming one of the first public parks in the newly established East Bay Regional Park District, approved by voters from several neighboring communities, including Oakland, Berkeley, Hayward, and Fremont.

Sequoyah Country Club, Oakland, Calif. O-206

SEQUOYAH COUNTRY CLUB. This is a view of the private course, which opened in the East Oakland hills in the 1910s.

65

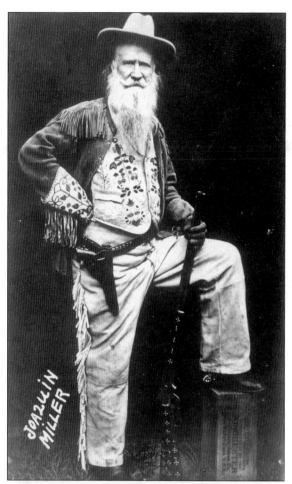

JoAQUIN MILLER

JOAQUIN MILLER (1841–1913). A colorful character who called himself the Poet of the Sierras, Miller roamed the early Western territories in the pioneer era during his youth. He began writing and lecturing in his middle age, gaining a following among those interested in the vanishing "wild, wild West." Finally settling in the hills above Oakland, he lived out his final days surrounded by admirers. Miller planted thousands of tree sprouts across the bare hills of his property, so the story goes, and built a modest cabin he called "the Hights," pictured below. His only daughter, Juanita, dedicated her life to perpetuating her father's memory following his death in 1913. She negotiated with the city to give over the newly wooded property for a public park.

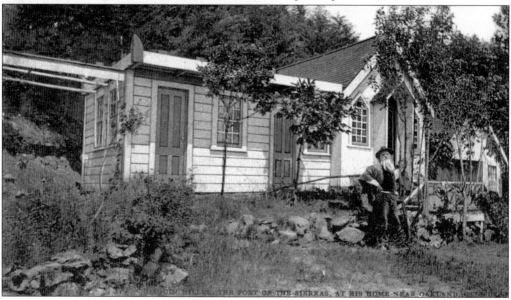

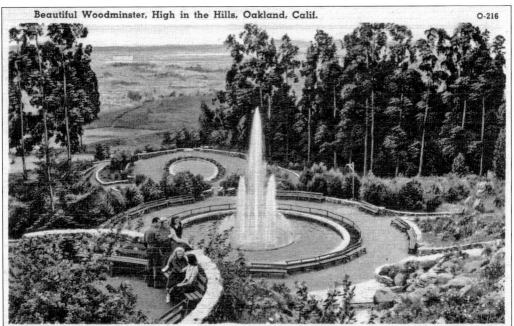

WOODMINSTER FOUNTAIN AND CASCADES. Frank Mott's wife, Gertrude, a member of the California Writer's Club, led an effort, beginning in the 1920s, to create a redwood grove and water cascade, dedicated to the state's writers and poets, on the hillside above Joaquin Miller's cabin. The ongoing project continued into the 1930s, growing in scope to include an outdoor amphitheater. The stonework for the cascade steps and retaining walls was done by Public Works Administration laborers and funded by the Depression-era Roosevelt Administration. In the photograph on the right, the amphitheater is visible on the hillside.

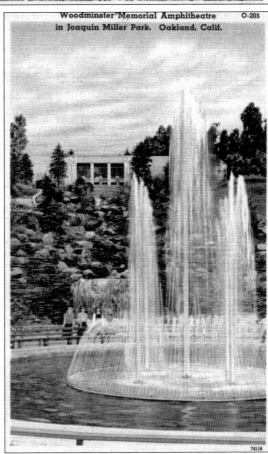

Woodminster Memorial Amphitheatre O-205
in Joaquin Miller Park, Oakland, Calif.

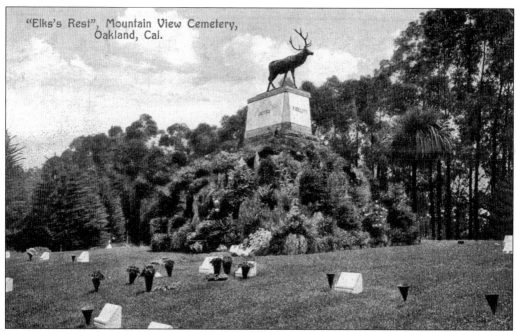

"Elks's Rest", Mountain View Cemetery, Oakland, Cal.

MOUNTAIN VIEW CEMETERY. Samuel Merritt was the first president of the association, formed in 1865 to establish Mountain View Cemetery. Oakland had already outgrown its two smaller cemeteries near the lake. Frederick Law Olmsted, famous for creating New York City's Central Park, was hired to lay out the 200-plus-acre cemetery, on a gradually rising slope overlooking the bay, two and one-half miles from downtown Oakland.

CHAPEL OF THE CHIMES. This is a view of the crematorium designed by architect Julia Morgan in the 1920s, located on Piedmont Avenue near the entrance to Mountain View Cemetery.

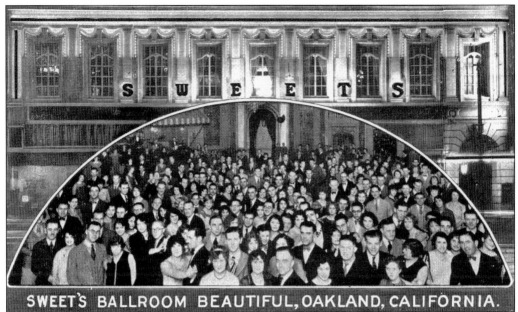

SWEET'S BALLROOM BEAUTIFUL, OAKLAND, CALIFORNIA.

SWEET'S BALLROOM BEAUTIFUL. William and Eugene Sweet, two brothers who enjoyed the Big Band scene of the 1930s, opened an establishment on Broadway called Sweet's Ballroom Beautiful. All the big-name entertainers of the day, from Duke Ellington and Tommy Dorsey to Count Basie, Fletcher Henderson, and Frank Sinatra, appeared at Sweet's during its heyday in the 1930s and 1940s.

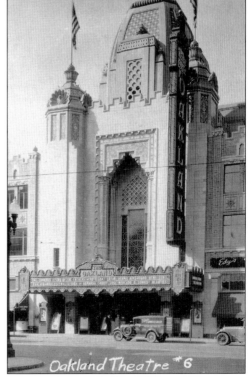

OAKLAND FOX THEATER. This fanciful "Brahamanian Temple/ Gateway to the Orient" movie palace opened on Telegraph Avenue in 1928. It was the largest theater on the Pacific Coast. Locally prominent Maury I. Diggs was the architect. In the 1970s, the old theater was saved from demolition, became a city landmark, and is currently awaiting renovation. Nearby is the art deco Paramount Theater on Broadway, which has already been successfully restored and is currently used for cultural events and performances.

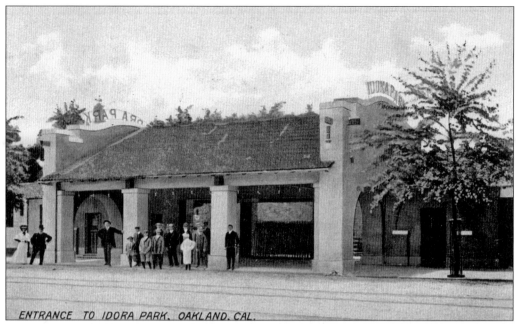

ENTRANCE TO IDORA PARK, OAKLAND, CAL.

IDORA PARK. Beginning in 1903, Key Route street cars ran eager patrons out to North Oakland's amusement playground called Idora Park. It was 17.5 acres from the west side of Telegraph Avenue to Shattuck Avenue, between Fifty-sixth and Fifty-eighth Streets. Strings of electric lights in the trees illuminated the nighttime skies. There was a skating rink, a "scenic railway" (early roller coaster), animal attractions, opera performances, and other entertaining concessions. It was a favorite destination for Jack London and his two daughters, who lived two streetcar stops down the line. Below, a circle swing was one of the many popular attractions that drew day-trippers to the amusement park.

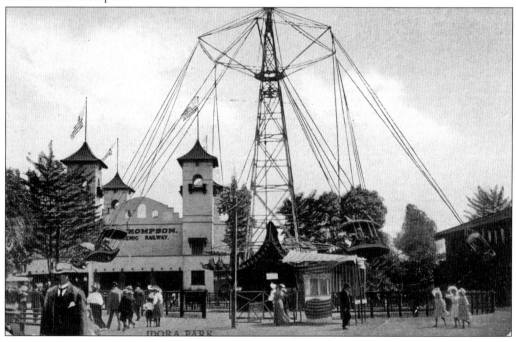

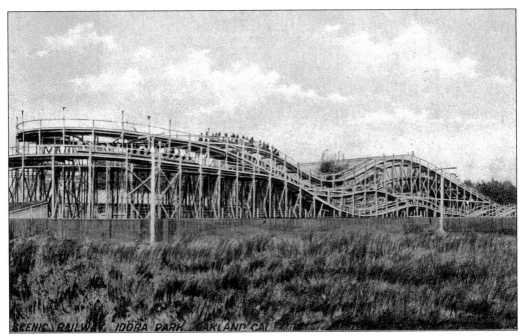

THOMPSON SCENIC RAILWAY, IDORA PARK. Here is one of the nation's early roller coasters. According to the history files, F. M. Smith bought a picnic ground, once belonging to the Peralta family, in order to transform it into the popular amusement park.

PERFORMERS, IDORA PARK. An open-air amphitheater, offering live musical comedy, was another of the park's featured attractions.

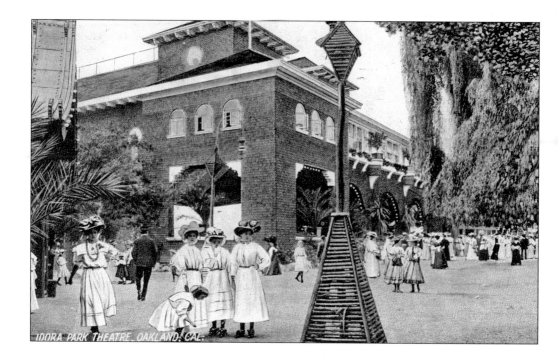

IDORA PARK THEATRE, OAKLAND, CAL.

SPENDING THE DAY AT IDORA PARK. In the aftermath of the 1906 earthquake, F. M. Smith's Realty Syndicate, owners of Idora Park, made the space available to those made homeless. Tents were set up for those in need of shelter. Below, Effie the Elephant poses with her trainer in the park.

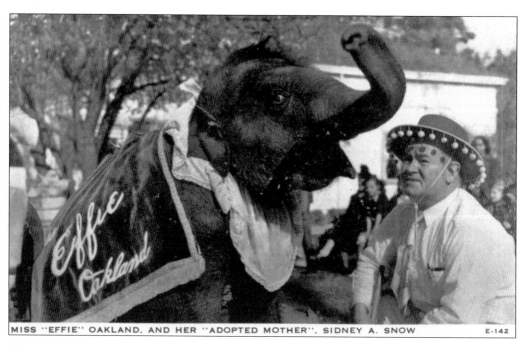

MISS "EFFIE" OAKLAND, AND HER "ADOPTED MOTHER", SIDNEY A. SNOW E-142

Five

HOTELS, APARTMENT DISTRICTS, AND CLUBS

As the concept of postcards caught on, buyers elected to mail cards back home to family and friends from where they happened to be staying; hence, views of hotels were plentiful. During the 1910s, 1920s, and 1930s, visitors to Oakland had several choices for accommodations, most of which had close access to nearby streetcar lines.

This era witnessed the advent of the apartment lifestyle, also enjoying popularity in Eastern cities such as New York, Philadelphia, and Chicago. In Oakland, handsome multiunit buildings began appearing in the lakeside district beginning in the 1920s. Mott and Davie (both of whom outlived their wives) spent their later years in accommodations such as these.

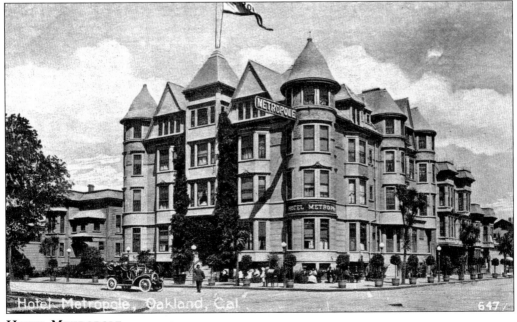

HOTEL METROPOLE.

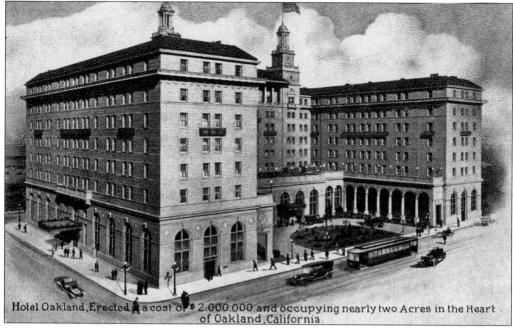

Hotel Oakland, Erected at a cost of $2,000,000 and occupying nearly two Acres in the Heart of Oakland, California.

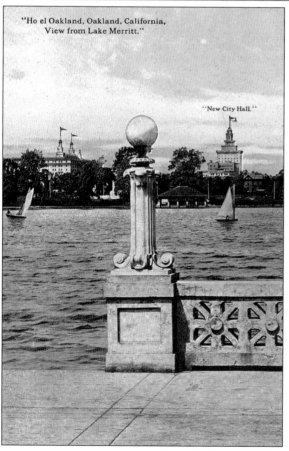

"Hotel Oakland, Oakland, California, View from Lake Merritt."

"New City Hall."

HOTEL OAKLAND. F. M. Smith, H. C. Capwell, and Edson Adams Jr., son of town founder Edson Adams Sr., were among the investors who financed the construction of the grand Hotel Oakland on Thirteenth Street, between Harrison and Alice Street, in 1913. The architectural firm Bliss and Faville created the design. At left is a view of the hotel from a vantage point across Lake Merritt, at the East Eighteenth Street boat landing. The boat landing was built in 1915 as part of the various lakeside park improvements paid for by public bonds. City hall is also visible in this view.

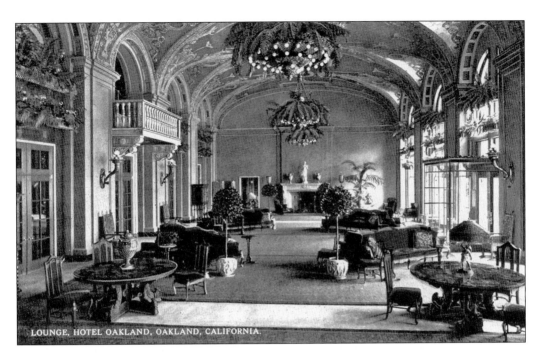

LOUNGE, HOTEL OAKLAND, OAKLAND, CALIFORNIA.

HOTEL OAKLAND. Presidents Wilson and Coolidge stayed at the hotel, and Charles Lindbergh, Amelia Earhart, and Mary Pickford were among the guests and celebrities who frequented the hotel during its heyday in the 1920s. The card above shows the entry lobby, and below, a packed dining room. Mayor Davie retired to live at the hotel in the early 1930s, regaling reporters and visitors with stories of the old days.

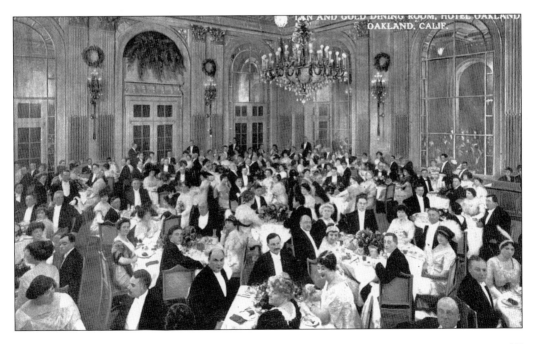

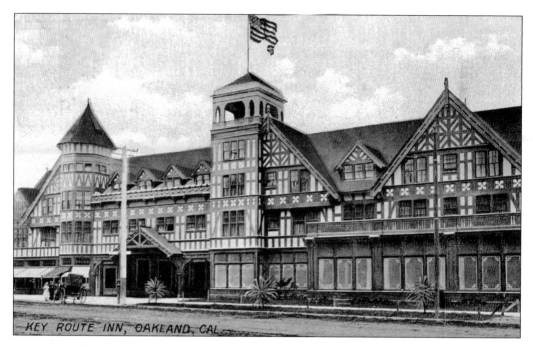

KEY ROUTE INN, OAKLAND, CAL.

KEY ROUTE INN. When Pres. William Howard Taft came to Oakland in 1911 to lay the cornerstone for city hall, he stayed at this half timbered–style inn on Broadway, owned by the Realty Syndicate. It was built in 1904 and was designed by architect Edward Foulkes. The Key Route streetcars ran right through the hotel, making a stop before continuing out to the long pier and the ferry terminal for the trip to San Francisco. The hotel was demolished in 1932, after a major fire gutted its interior. The Breuner's Furniture Store was built in its place (see Chapter Three).

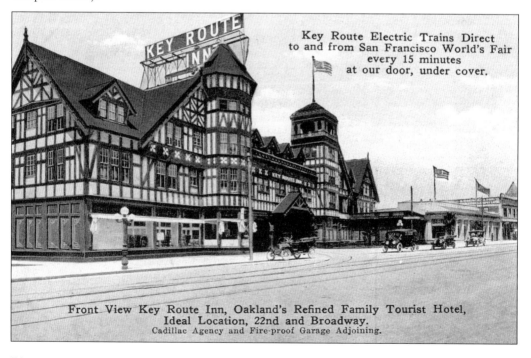

Key Route Electric Trains Direct to and from San Francisco World's Fair every 15 minutes at our door, under cover.

Front View Key Route Inn, Oakland's Refined Family Tourist Hotel, Ideal Location, 22nd and Broadway.
Cadillac Agency and Fire-proof Garage Adjoining.

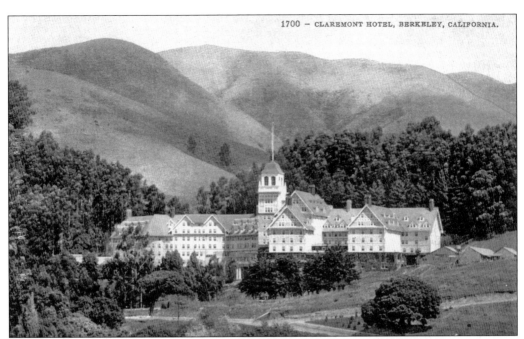

CLAREMONT HOTEL. F. M. Smith's Realty Syndicate had another grand hotel in the half-timbered Tudor style, completed by 1915 at the end of the Claremont streetcar line in the hills bordering Berkeley. The architect was Charles W. Dickey. The hotel resembled its sister hotel, the Key Route Inn, with its half-timbered detailing. Tourists coming out for the 1915 Panama Pacific Exhibition in San Francisco were among the hotel's first guests. The city boundary between Oakland and Berkeley was redrawn various times over the years. The Claremont has at certain periods "stood" in Berkeley. Since 2001, the hotel has been a City of Oakland historic landmark.

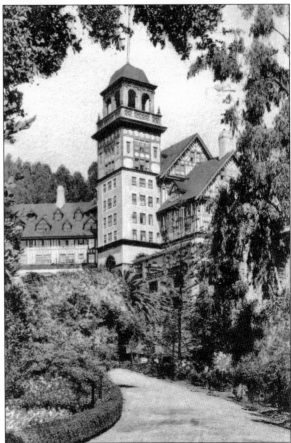

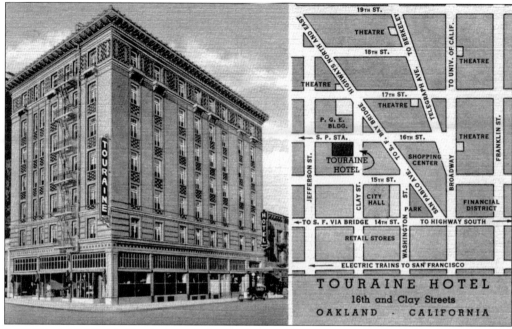

TOURAINE HOTEL
16th and Clay Streets
OAKLAND · CALIFORNIA

TOURAINE HOTEL AND HOTEL HARRISON. Both the Touraine Hotel on Clay Street and the Hotel Harrison on Harrison Street accommodated guests attending the 1915 Panama-Pacific International Exposition. Following the 1989 earthquake, both buildings were renovated. Currently they provide long-term, affordable housing to downtown residents.

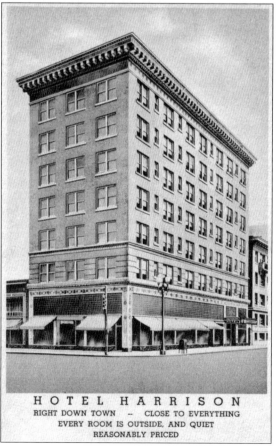

HOTEL HARRISON
RIGHT DOWN TOWN — CLOSE TO EVERYTHING
EVERY ROOM IS OUTSIDE, AND QUIET
REASONABLY PRICED

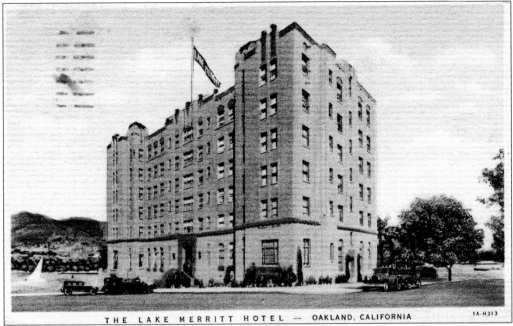

THE LAKE MERRITT HOTEL — OAKLAND, CALIFORNIA

LAKE MERRITT APARTMENT HOTEL.
This hotel was designed by prominent California architect William Weeks. It opened in 1927. Mayor Davie gave it high praise that year in his state of the city speech. In the 1990s, the hotel was completely refurbished and received landmark designation. Patrons of the hotel's terrace dining room, shown at right, had a beautiful vantage point overlooking the lake.

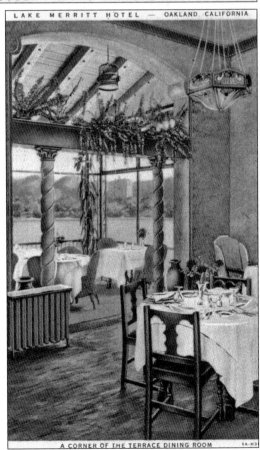

LAKE MERRITT HOTEL — OAKLAND, CALIFORNIA

A CORNER OF THE TERRACE DINING ROOM

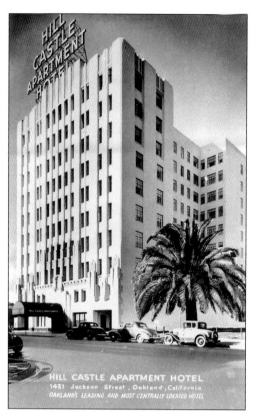

HILL CASTLE APARTMENT HOTEL. This 10-story hotel was designed by the firm Miller and Warnecke in 1930. The presence of so many residential, high-rise buildings during the 1920s is indicative of the city's robust population growth.

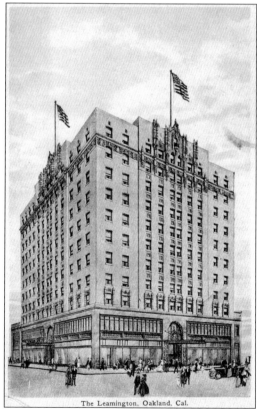

The Leamington, Oakland, Cal.

LEAMINGTON HOTEL. William Weeks designed this hotel on Franklin Street. It opened in 1925.

80

SAN PABLO HOTEL. Architect Charles W. Dickey designed the San Pablo Hotel at San Pablo Avenue and Twentieth Street, where Grove Street intersects.

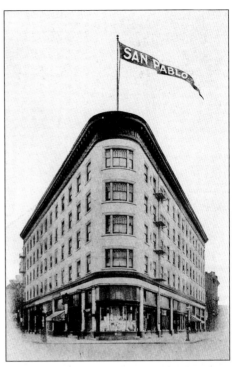

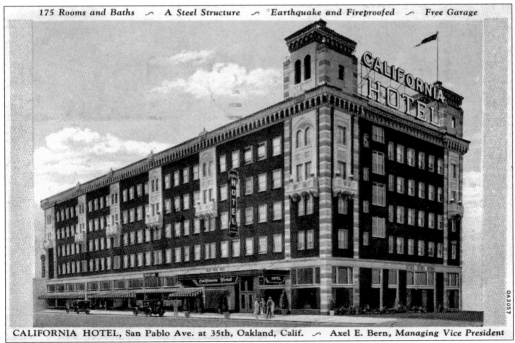

175 Rooms and Baths ⌒ A Steel Structure ⌒ Earthquake and Fireproofed ⌒ Free Garage

CALIFORNIA HOTEL, San Pablo Ave. at 35th, Oakland, Calif. ⌒ Axel E. Bern, Managing Vice President

CALIFORNIA HOTEL. The California Hotel, near the Emeryville border, was also located on San Pablo Avenue, considered to be the major north-south artery in the era before World War II. This preceded the creation of the East Bay highway network. The Mediterranean-style hotel was designed by the locally prominent architect Clay Burrell. It became a city landmark and was renovated for affordable housing in the 1980s.

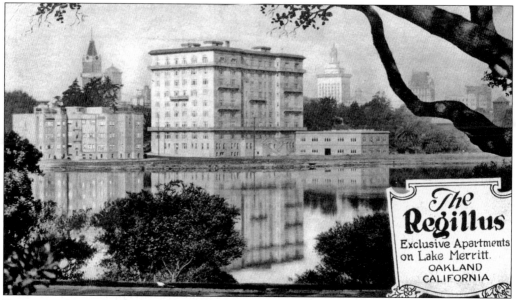

REGILLUS APARTMENTS. In the 1920s, some of the older Victorian-style estates began to be replaced by luxury apartment buildings, such as the Regillus, which was built on Jackson and Nineteenth Streets, by architect Willis Lowe.

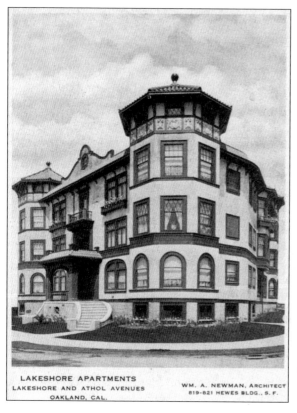

LAKESHORE APARTMENTS. Architect William A. Newman designed the Mission Revival–style Lakeshore Apartments near the East Eighteenth Street boat landing.

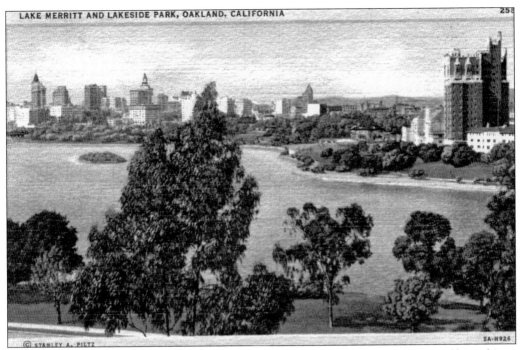

BELLEVUE STATEN APARTMENTS. Built in 1928, this 16-story building was designed by architect H. C. Baumann, who also built high-rise apartments in San Francisco during this period.

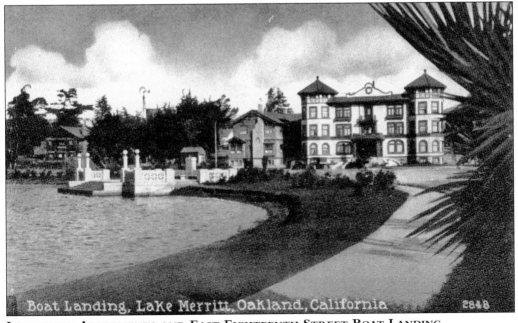

Boat Landing, Lake Merritt, Oakland, California

LAKESHORE APARTMENTS AND EAST EIGHTEENTH STREET BOAT LANDING.

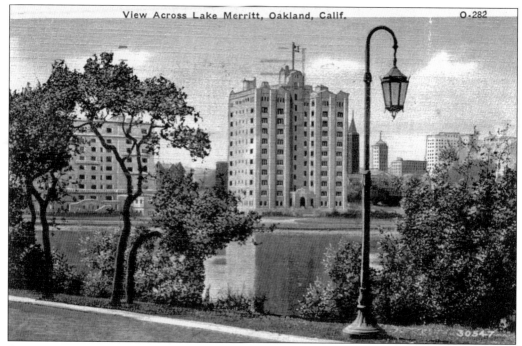

APARTMENTS AT 244 LAKESIDE DRIVE. This luxury apartment complex was designed by architect Maury Diggs. According to the files, prominent citizens such as *Tribune* publisher Joseph P. Knowland were longtime residents.

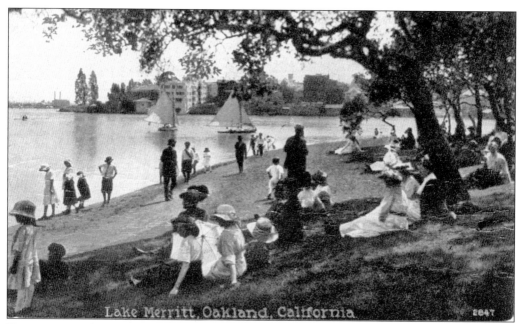

ENJOYING AN AFTERNOON AT THE LAKE, C. 1900.

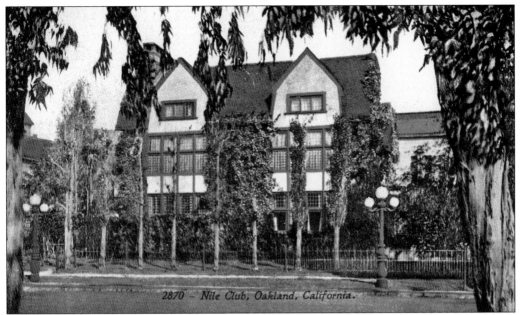

NILE CLUB BUILDING. In 1890, architect A. Page Brown designed this residence on Thirteenth Street, between Grove and Castro Streets, in the newly popular Arts and Crafts style. The Nile Club, a private men's social organization, acquired the home some years later for their club meetings and activities. During World War II, it served as a USO hall.

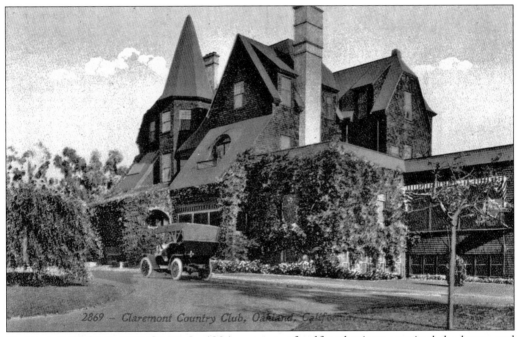

CLAREMONT COUNTRY CLUB. In 1904, a group of golf enthusiasts acquired the home and property of Horatio Livermore and established the Claremont Country Club golf course. A 1927 fire destroyed the old mansion, and a new clubhouse, which is still standing, was soon built in its place.

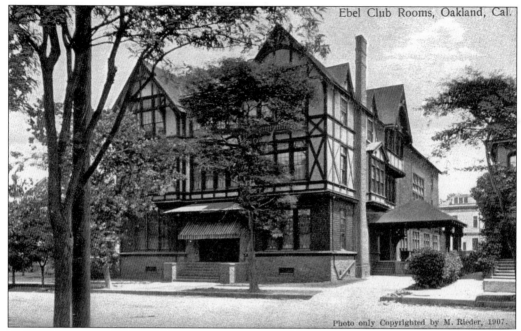

Ebel Club Rooms, Oakland, Cal.

Photo only Copyrighted by M. Rieder, 1907.

EBELL SOCIETY CLUBHOUSE. The Ebell Society was formed in 1884 by a cross section of Oakland women interested in the arts, music, nature, and current events. They hosted talks by prominent lecturers of the day and entertained at their downtown clubhouse building on Harrison Street. Frank Mott's wife, Gertrude, served a term as president.

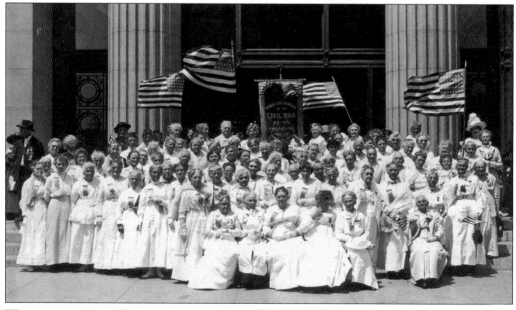

WOMEN AND GIRL WORKERS OF THE CIVIL WAR. In this view, a group poses for a reunion, *c.* 1920, in front of city hall.

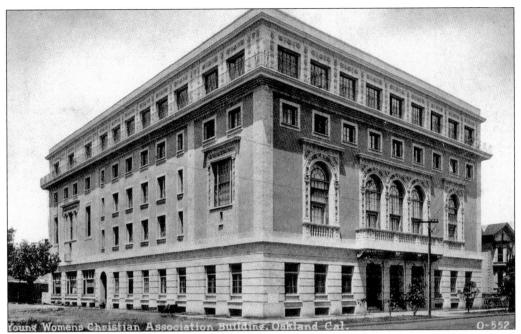

YWCA. The YWCA Building on Webster Street was designed by architect Julia Morgan, and it is the first of several YWCAs designed by her during her 40-year career. According to the files, Miss Morgan made use of her university sorority connections to receive commissions. The president of the Oakland YWCA was one such connection.

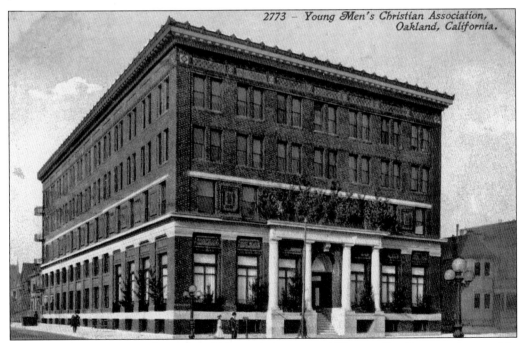

YMCA. The YMCA was located on Telegraph Avenue and Twenty-first Street and opened in 1910, one year before the YWCA. The architect was William C. Hays. Following restoration after the 1989 earthquake, it was reopened as affordable housing.

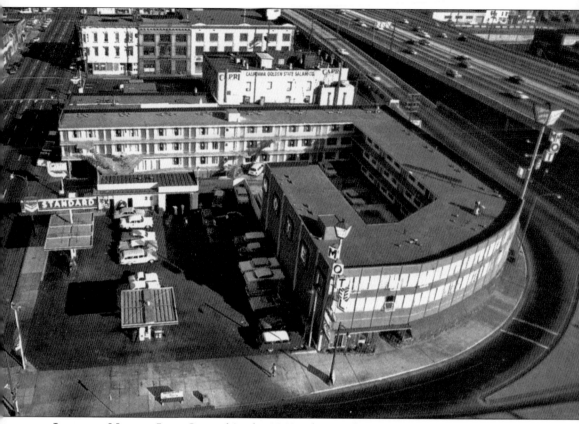

LONDON MOTOR INN. Opened in the 1960s, the London Motor Inn adapted its layout to its location, alongside the freeway off-ramp, near Fourth Street and Broadway. The days of hotels standing next to streetcar lines was long over. The I-880 Nimitz Freeway, named for World War II admiral Chester Nimitz, was the first to be built in the East Bay in 1958. It extended from the east end of the bay bridge, 41 miles south to San Jose.

Six

HOSPITALS, CHURCHES, AND SCHOOLS

During the heyday of postcards, views of hospitals, churches, and schools proved to be popular topics. A district in central Oakland known as Pill Hill was the location for three health institutions, starting in the early 1900s. A decade earlier, a few blocks away on Broadway near Moss Park, a group of women dedicated themselves to founding a hospital for the community they called "Fabiola."

From the outset, schools and institutions of higher learning in Oakland such as St. Mary's College, Mills College, and Holy Names, attracted students from all over the United States. Several landmark houses of worship, many still standing, have been pictured frequently in postcards through the years as well.

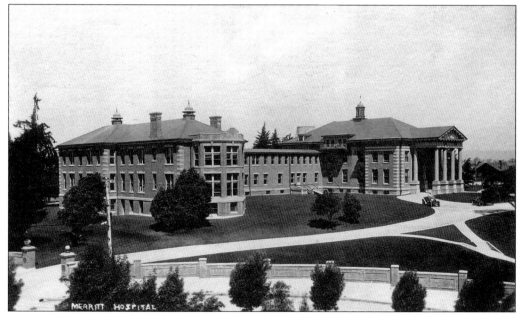

SAMUEL MERRITT HOSPITAL. Mayor Samuel Merritt, a doctor by training, left provisions in his will for a hospital to be built for the residents of Oakland. His wishes were carried out, and the hospital and nursing school were constructed on the Broadway side of what came to be known as "Pill Hill," in 1909.

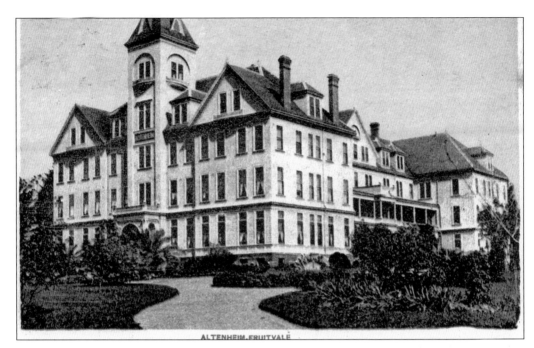

ALTENHEIM.FRUITVALE

ALTENHEIM RETIREMENT HOME. In the late 19th century, German immigrants living in San Francisco established a retirement home across the bay in the sunny Fruitvale District of Oakland. The building in this postcard view suffered a fire and was replaced with the facility seen in postcard below. The property sat atop a hill and was surrounded by grounds with garden paths, trees, and flowering vines. The facility was located not far from Dimond Park (named for pioneer settler Hugh Dimond), where "bier gardens" served refreshments to day-tripping visitors arriving on the Highland Park and Fruitvale Electric Railway.

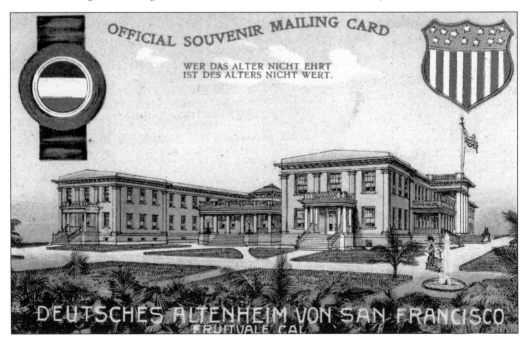

OFFICIAL SOUVENIR MAILING CARD

WER DAS ALTER NICHT EHRT
IST DES ALTERS NICHT WERT.

DEUTSCHES ALTENHEIM VON SAN FRANCISCO
FRUITVALE CAL

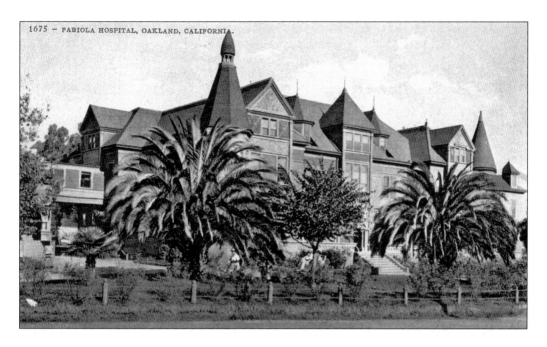

FABIOLA HOSPITAL. In the mid-1880s, a group of women decided to sponsor a community hospital because Oakland was lacking in medical facilities at that time. They received a donation of two and a half acres of land north of town on upper Broadway, across from today's Mosswood Park. Anthony Chabot was the benefactor. They launched the building campaign with a donation of $50 apiece. The name "Fabiola" refers to the name of a Roman noblewoman who was said to have founded the first hospital for the poor, so the story goes. Fabiola operated until the late 1930s, when it was sold. Kaiser Permanente Hospital occupies the site today.

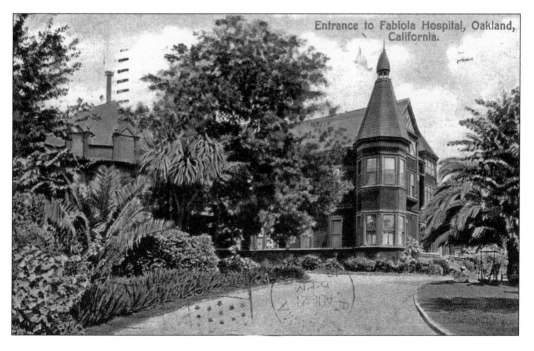

Entrance to Fabiola Hospital, Oakland, California.

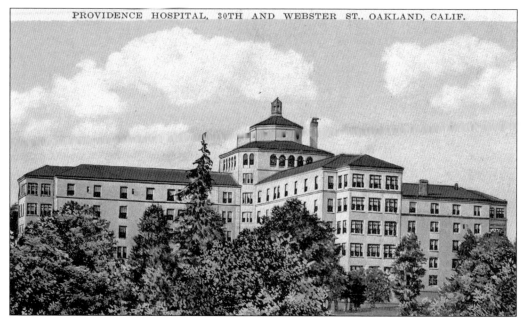

PROVIDENCE HOSPITAL. A quarter of a mile down Broadway, at Twenty-sixth Street, the Sisters of Charity from Montreal established a hospital in 1904. Two years later, they were flooded with patients and refugees from the earthquake and fire. For weeks, they fed up to 800 people a day. Their "new" building, pictured here, was built in 1926 on Summit and Orchard Street.

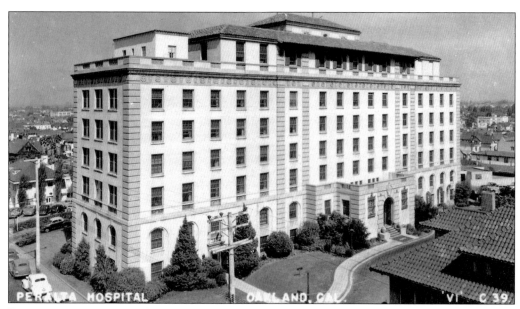

PERALTA HOSPITAL. Peralta Hospital opened in 1928 as a private facility with up-to-date medical equipment, the concept of a group of five prominent physicians. The hospital was erected on Orchard Street, on the Telegraph Avenue side of Pill Hill. For their new hospital, the doctors chose the name "Peralta," in honor of the Mexican rancho family who once controlled land granted to the father, Don Luis Peralta, by the king of Spain for many years of military service.

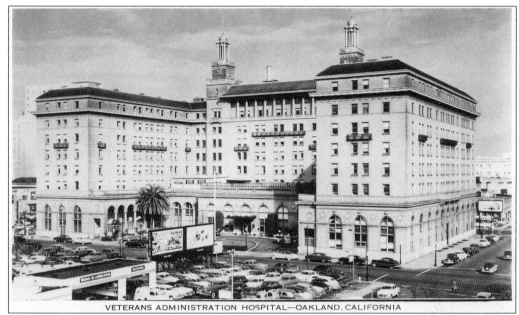

VETERANS ADMINISTRATION HOSPITAL—OAKLAND, CALIFORNIA

VETERANS HOSPITAL (FORMERLY HOTEL OAKLAND). During World War II, the formerly grand Hotel Oakland was converted into a veteran's hospital for military personnel. After several years, it was closed, and its future was uncertain until developers made the hotel a landmark and renovated it for affordable housing in the 1980s.

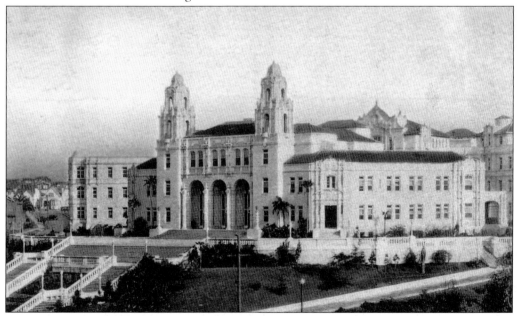

ALAMEDA COUNTY HOSPITAL. Across town from Pill Hill, on another prominent hilltop east of the lake, Alameda County opened an impressive Spanish Colonial Revival–style hospital facility in 1924. Funds for the project came from a $1.8 million bond measure and county architect Henry Meyers designed the complex. Notable features included two tall bell towers, and twin multilevel staircases leading to a large open terrace. It was considered one of the most beautiful hospitals of its type in the country when it opened.

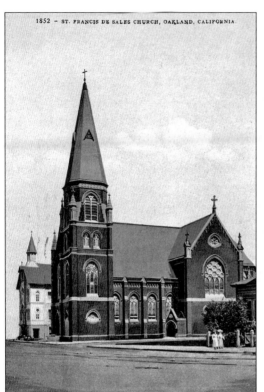

ST. FRANCIS DE SALES CATHOLIC CHURCH. According to the history files, an Irish lady named Mary Canning (the cook and housekeeper for town founder Horace Carpentier) invested her savings wisely in real estate opportunities throughout the fast growing city of Oakland. She was therefore able to donate funds to build this impressive, Gothic-style, masonry Roman Catholic church, St. Francis de Sales, on Grove and Twenty-eighth Street, in 1893. Its 178-foot-tall bell spire was visible for miles in all directions. In 1962, the church was reconsecrated as the cathedral for the newly created Oakland Diocese. Unfortunately, de Sales was demolished after suffering damage in the 1989 Loma Prieta Earthquake.

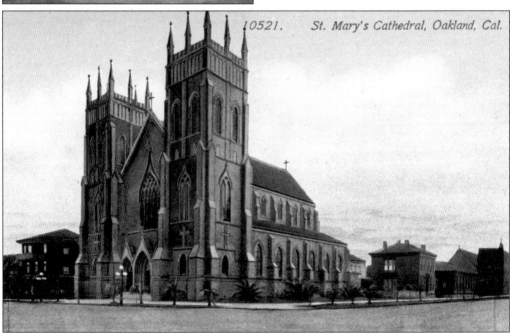

ST. MARY'S CATHOLIC CHURCH. The church, on Jefferson and Eighth Streets, was constructed between 1868 and 1872 on property donated by Horace Carpentier. It is the "mother" church to all other Catholic churches in Alameda and Contra Costa Counties. When de Sales was closed following the 1989 earthquake, the two congregations merged.

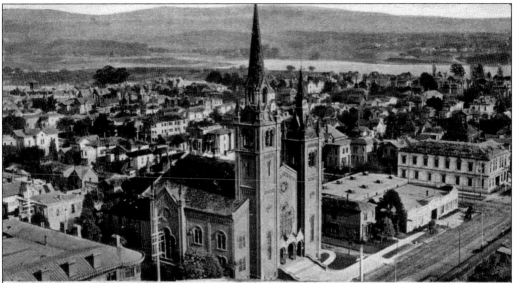

Oakland, Cal. Lake Merritt, from Union Bank. (East Oakland and Piedmont Heights in the Background).

FIRST PRESBYTERIAN CHURCH, FOURTEENTH AND FRANKLIN STREETS. First Presbyterian was among the earliest Protestant churches to organize in the East Bay. The congregation had been meeting in various locations for several years before they built this wood-frame church on Fourteenth Street, seen here with a view of the lake and hills in the background.

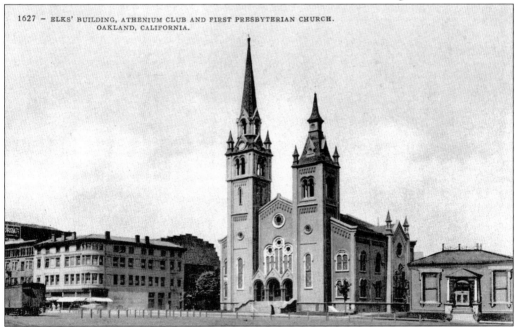

1627 – ELKS' BUILDING, ATHENIUM CLUB AND FIRST PRESBYTERIAN CHURCH. OAKLAND, CALIFORNIA.

FIRST PRESBYTERIAN CHURCH WITH ATHENIAN CLUB ON THE LEFT. This second view of First Presbyterian shows its neighbor, the Athenian Club Building (on the left), designed by early prominent architect Walter Mathews. The Athenians were a private social organization for men only. Today, the club building still remains, but the church property was sold in 1915, and the congregation moved "uptown" to Broadway and Twenty-sixth Street.

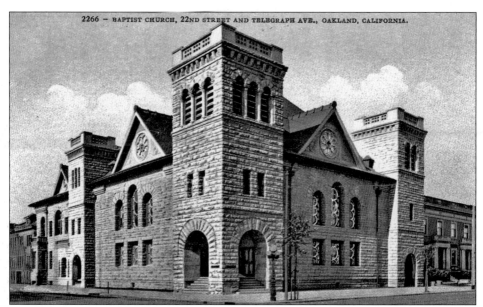

FIRST BAPTIST CHURCH. This masonry church on Telegraph and Twenty-first Street, with beautiful stained-glass windows, was just newly opened when the 1906 earthquake struck, causing considerable damage to the facade. Architect Julia Morgan, who had attended Sunday school there as a child, was called upon to reconstruct the building and design a new sanctuary space. It was one of her first and most notable assignments. In 2004, the congregation members celebrated their 150th anniversary.

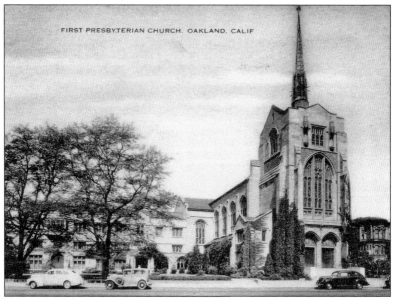

FIRST PRESBYTERIAN CHURCH, OAKLAND, CALIF

FIRST PRESBYTERIAN CHURCH, BROADWAY AND TWENTY-SIXTH STREET. In 1916, noted architect William C. Hays designed this next church for the Presbyterian congregation. Located on Broadway between Twenty-sixth and Twenty-seventh Streets, the church is steel framed with reinforced concrete, in an English Gothic style. Its spire rises 178 feet. The church is known for its beautiful, stained-glass windows depicting the congregation's long history in Oakland, and a magnificent pipe organ housed in the sanctuary.

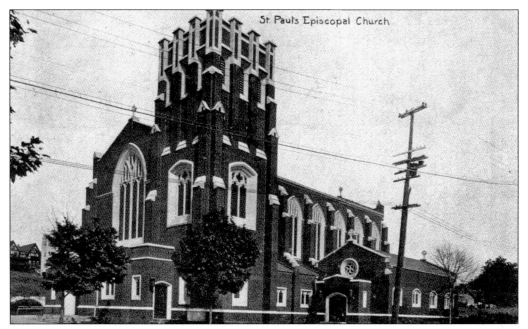

ST. PAUL'S EPISCOPAL CHURCH. This congregation, originally formed in 1871, also relocated in the early years, leaving its previous site at Fourteenth and Harrison Streets, when the proposed Hotel Oakland was to be erected there. This is a view of their 1912 Gothic Revival–style church by noted architect Benjamin Geer McDougall, on Montecito and Bay Place.

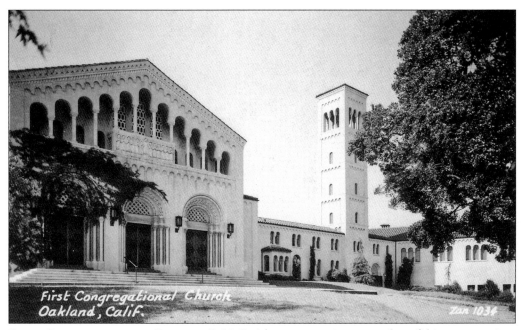

FIRST CONGREGATIONAL CHURCH. F. M. Smith was a prominent member of this congregation. The church on Harrison and Twenty-seventh Street was designed by noted architect John Galen Howard and opened its doors in 1925. The congregation members, led by Smith, were among those who responded quickly to the plight of 1906 refugees of the earthquake.

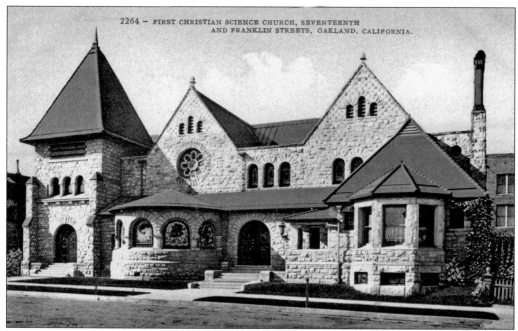

2264 – FIRST CHRISTIAN SCIENCE CHURCH, SEVENTEENTH
AND FRANKLIN STREETS, OAKLAND, CALIFORNIA.

FIRST CHURCH OF CHRIST SCIENCE. This masonry Richardsonian Romanesque–style church on Franklin and Seventeenth Streets, designed by Henry Schulze and opened in 1902, survived the 1906 earthquake with little or no damage. When it was first built, it stood in a neighborhood of homes, but over the years, commercial development replaced residential.

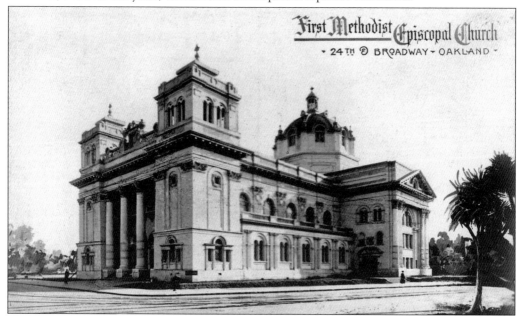

First Methodist Episcopal Church
- 24TH & BROADWAY - OAKLAND -

FIRST METHODIST CHURCH. In 1912, the Methodists took full advantage of their prominent site on Twenty-fourth Street and Broadway, erecting a stately landmark that was said to be inspired by St. Paul's Cathedral in London and St. Peter's Basilica in Rome. The architect was Stephen McPherson. Unfortunately, in 1983, it was heavily damaged by a fire and had to be demolished.

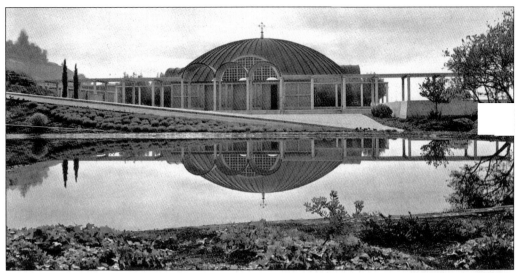

GREEK ORTHODOX CATHEDRAL OF THE ASCENSION. Greek immigrants were among the many who came to Oakland in the early years, attracted to the number of jobs available in the railroad yards and docks. A Greek Orthodox congregation was organized in 1917, and its church was built on Brush Street in 1920. Forty years later, in 1960, the congregation moved to "Temple Hill," on Lincoln Avenue, overlooking East Oakland. Architect Robert Olwell designed a cathedral complex with meeting rooms, a gymnasium, dining hall, and classrooms. The dome over the sanctuary is sheathed in copper and spans 120 feet across.

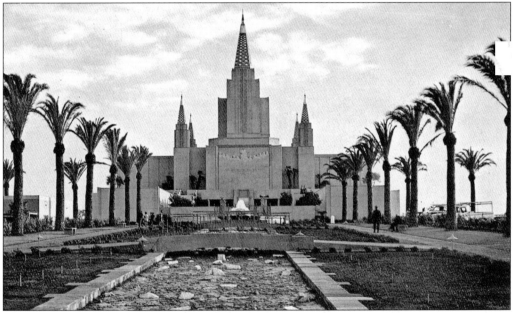

TEMPLE, CHURCH OF JESUS CHRIST OF LATTER-DAY SAINTS. In the 1850s, members of the church were among the earliest to arrive in California and the East Bay. Property for this complex, atop "Temple Hill" with an incredibly commanding view, was purchased in 1943. Construction started in 1961, and the dedication took place in November 1964. The temple is such a prominent and navigational landmark that ships entering San Francisco Bay use it for navigation purposes.

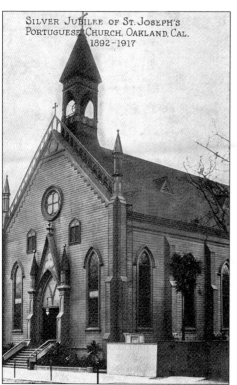

St. Joseph's Portuguese Church. Many Portuguese immigrants found their way to Alameda County over the years. St. Joseph's Church was located on Seventh and Chestnut Streets in West Oakland. It was demolished in the 1960s to make way for urban renewal.

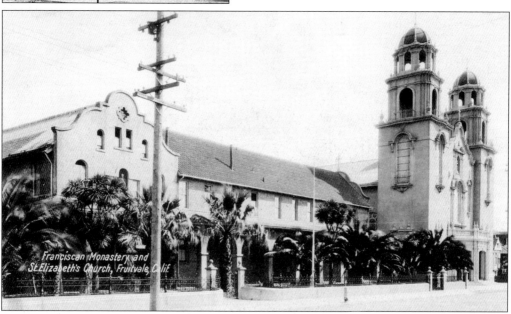

St. Elizabeth's Catholic Church. Initially St. Elizabeth's Church was established to be a place of worship for German-speaking faithful throughout the Bay Area. The first wood-frame church was built on the site of the present church in the Fruitvale District of East Oakland in the late 1800s. It was replaced in 1920 by the one seen here, notable for its twin 60–foot Baroque Revival–style bell towers. The architect was John J. Foley. Currently, the congregation is very diverse, with Hispanic and Southeastern Asian worshippers.

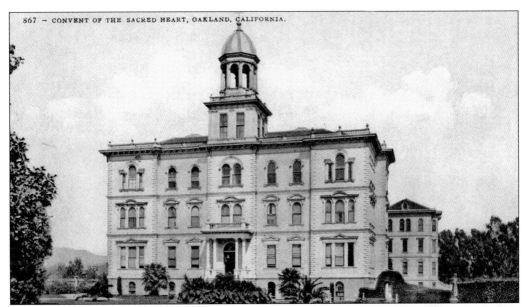

CONVENT OF THE SACRED HEART. The early days of Holy Names College can be traced back to 1868, when a group of Canadian nuns came, at the invitation of Rev. Michael Aloysius King of St. Mary's Catholic Church, and opened a convent school for girls on the west shore of Lake Merritt. From that modest beginning, the institution grew to become an undergraduate school and college, and over the years, they developed their lakeshore campus with buildings, grounds, and gardens. Holy Names moved to the Redwood Heights district in the Oakland hills in the late 1950s, after selling their lake property to Kaiser Industries (see Chapter Seven).

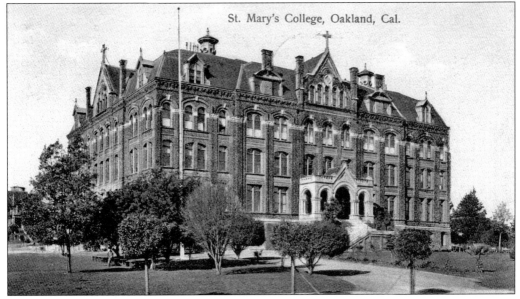

St. Mary's College, Oakland, Cal.

ST. MARY'S COLLEGE ON BROADWAY. St. Mary's College was founded in 1863 in San Francisco by the Christian Brothers. In 1887, they moved to Broadway, near Thirtieth Street, erecting this impressive masonry structure called affectionately, "the old brick pile." The building served the college well, but was eventually outgrown. The college moved to Moraga in 1930, and "the old brick pile" was demolished soon after by the new owner, an automobile dealership.

101

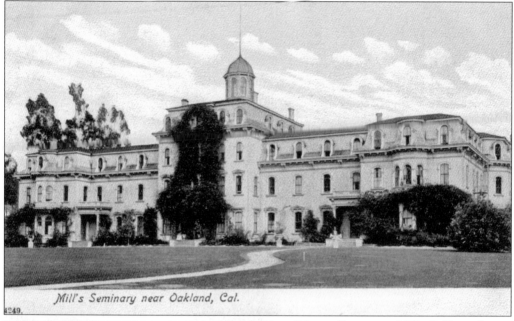

Mill's Seminary near Oakland, Cal.

TO THE HOCKEY FIELD-MILLS COLLEGE

MILLS COLLEGE. Mills College also has a long history, dating back to 1852 when Susan and Cyrus Mills took over the Young Ladies Seminary, a school for prosperous gold rush miners' daughters in Benicia (at that time, briefly the state capital). In 1871, Mr. and Mrs. Mills moved the school, "lock, stock, and barrel," to a vacant 55-acre parcel in the hills several miles east of Oakland. Mills Hall, seen above, was the first building built for the relocated school. According to the history files, the Mills campus had very few trees in the early years. Cyrus Mills, who had been a missionary in Ceylon and Japan, planted thousands of saplings that soon transformed the property into the tree-shaded campus it is today.

LANDMARKS OF MILLS COLLEGE. One of the most famous landmarks on the Mills campus is the El Campanile Bell Tower, designed by Julia Morgan in 1904—an early example of reinforced concrete on the West Coast. The cast-iron bells came from the 1893 Chicago World's Fair. Mary Smith, wife of "Borax" Smith, paid for the tower to house the bells. The campus library was also designed by Julia Morgan.

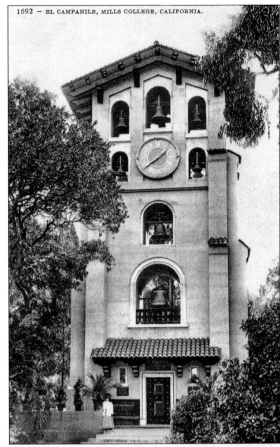

1692 — EL CAMPANILE, MILLS COLLEGE, CALIFORNIA.

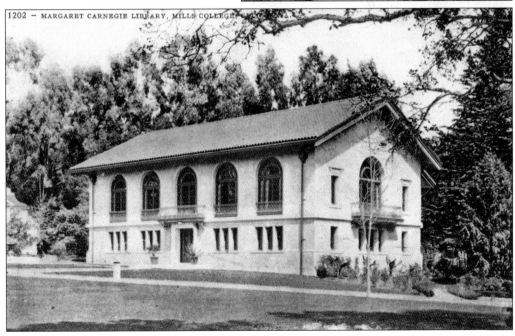

1202 — MARGARET CARNEGIE LIBRARY, MILLS COLLEGE

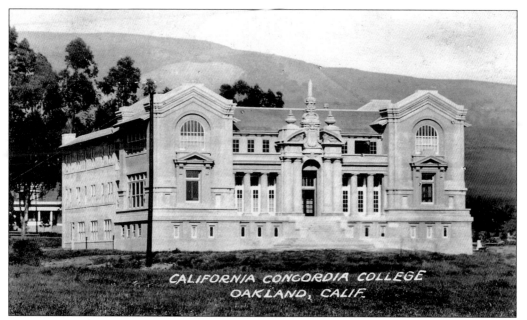

CALIFORNIA CONCORDIA COLLEGE. This institution on Sixty-fourth Avenue and Brann Street was built as a seminary for young Lutherans studying for the ministry. It stood on eight acres, and closed its doors in 1972 due to declining enrollment Today the site is a city park.

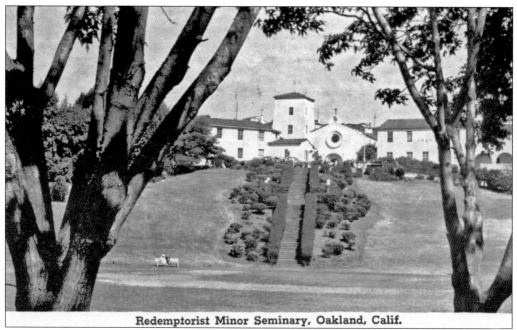

Redemptorist Minor Seminary, Oakland, Calif.

HOLY REDEEMER COLLEGE. In the 1920s, the Redemptorist Order founded a seminary for young men on a hilltop site, not far from Knowland Park Zoo. Today it is a retreat center.

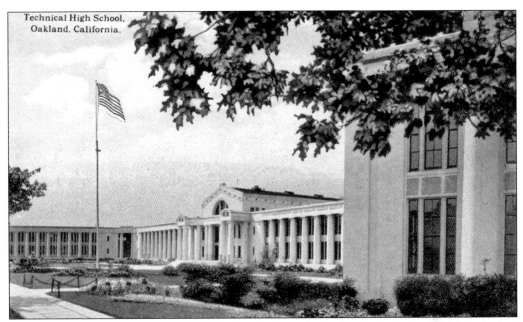

Technical High School, Oakland, California.

OAKLAND TECHNICAL HIGH SCHOOL. Architect John J. Donovan designed this technical high school on Broadway between Forty-second and Forty-fifth Streets in North Oakland. In 1911, a $2.6 million voter-approved bond measure provided funds for this campus, as well as several other schools, a reflection of Oakland's population growth during this period. Tech's main building was saved from the wrecking ball in the 1970s, even while many other schools throughout California were being torn down instead of being earthquake retrofitted.

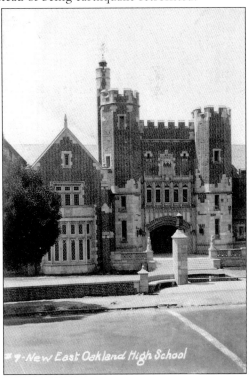

CASTLEMONT HIGH SCHOOL. Another school bond was approved by voters in 1925, and this high school, initially called East Oakland High, was built in 1929 by noted architects Miller and Warnecke. The school was located on MacArthur Boulevard and Eighty-fifth Avenue, not far from the Chevrolet Motor Plant that at that time was attracting so many workers and their families. The Tudor Revival style of the campus induced the school board to rename the school Castlemont High. Unlike Oakland Tech, Castlemont's main building was not renovated, and a 1970s replacement offers none of the historic character.

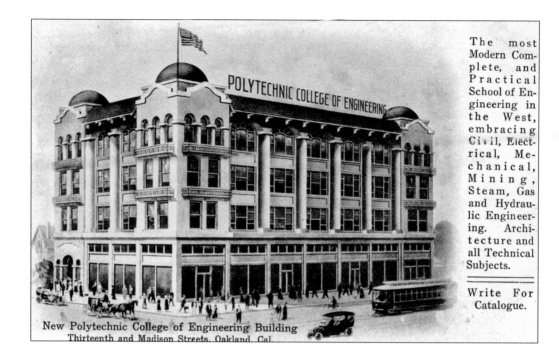

The most Modern Complete, and Practical School of Engineering in the West, embracing Civil, Electrical, Mechanical, Mining, Steam, Gas and Hydraulic Engineering. Architecture and all Technical Subjects.

Write For Catalogue.

New Polytechnic College of Engineering Building
Thirteenth and Madison Streets, Oakland, Cal.

POLYTECHNIC COLLEGES. In 1898, Willis Gibson founded both the Polytechnic College of Engineering and Polytechnic Business College in downtown Oakland. They stood a block apart on Twelfth and Thirteenth Streets, at Harrison and Madison Streets. The architect was A. W. Smith.

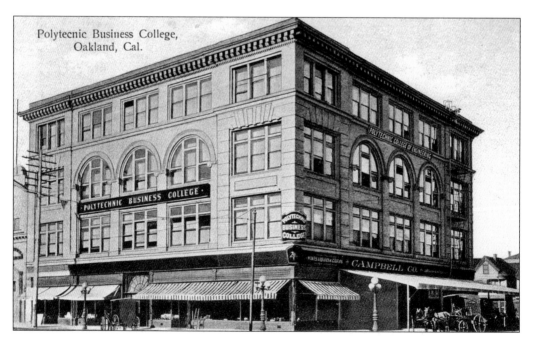

Polytecnic Business College, Oakland, Cal.

106

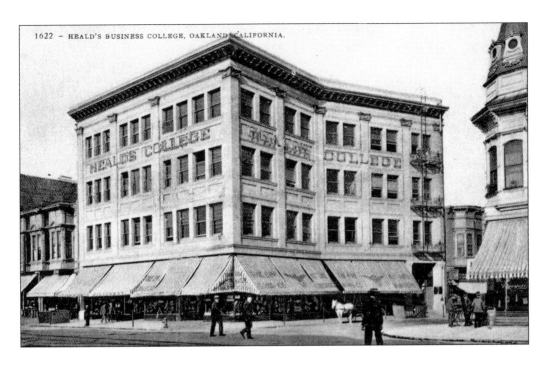

HEALDS COLLEGE. Founder Edward P. Heald lost everything in the San Francisco earthquake and fire of 1906. Like so many others, he moved to Oakland and started over, opening his business college on Sixteenth Street at San Pablo Avenue, close to banks and other commercial institutions. The typing department is pictured below.

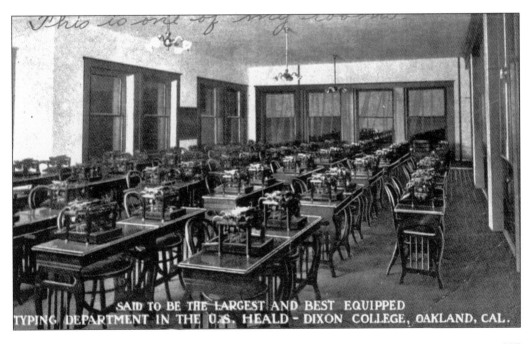

SAID TO BE THE LARGEST AND BEST EQUIPPED TYPING DEPARTMENT IN THE U.S. HEALD - DIXON COLLEGE, OAKLAND, CAL.

PATHWAY, CALIFORNIA COLLEGE OF ARTS AND CRAFTS,
OAKLAND, CALIFORNIA
WRITE FOR CIRCULAR

CALIFORNIA COLLEGE OF ARTS AND CRAFTS. Just like Mr. Heald on the previous page, art school professor Frederick Meyer was forced to flee San Francisco in 1906 and start a new school, first in Berkeley and later, in 1920, in north Oakland on the former estate of the Treadwell mining family. The tree-shaded grounds of the property offered inspiration for the students' landscape sketches.

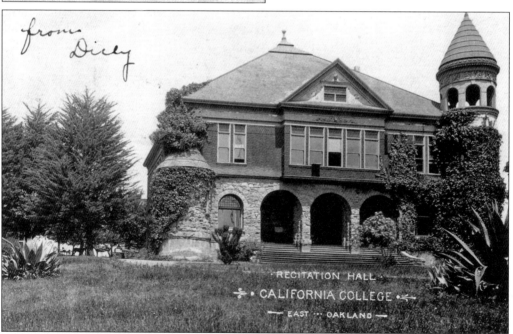

CALIFORNIA COLLEGE OF EAST OAKLAND. According to the files, this small private college was replaced by the buildings and grounds of Highland Hospital (see page 93).

Seven

THE POST-MOTT AND
DAVIE YEARS

As the Great Depression dawned, Oakland and the East Bay, like most other metropolitan areas in America, experienced a marked slowdown in growth. Mayor Davie retired in 1931 after 16 years in office, living out his final days at the once bustling, but still elegant, Hotel Oakland on Thirteenth Street. He died in 1934 at age 84.

Frank Mott continued to work at city hall into the 1950s on city right-of-way issues. He resided at the stately Athens Club on Clay Street (see Chapter Eight), two blocks from his office, until his death in 1958 at age 92.

Global war in the 1940s brought changes yet again to Oakland. With shipbuilding and other military support enterprises generating employment and attracting workers from throughout the United States, Oakland's population soared.

A new generation of postcard manufacturers were inspired by an entertainment and restaurant district named for famed writer and native son Jack London, which opened on the waterfront in 1951. Lakeside Park's fanciful Fairyland, also opening to visitors in the 1950s, was said to have influenced none other than Walt Disney.

A "state-of-the-art" sports complex completed in the 1960s hosted professional baseball, football, and basketball teams. In the 1970s, Oakland, ever the innovator in public transportation, became the center of operations for the Bay Area Rapid Transit District (BART). These landmarks, too, were commemorated through the production and sale of postcards.

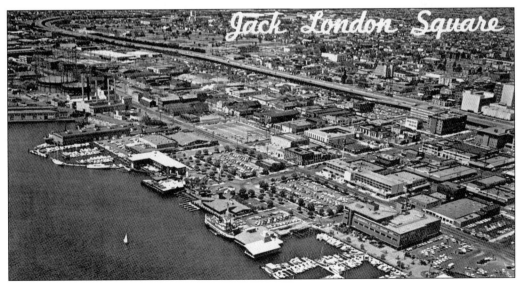

JACK LONDON SQUARE.

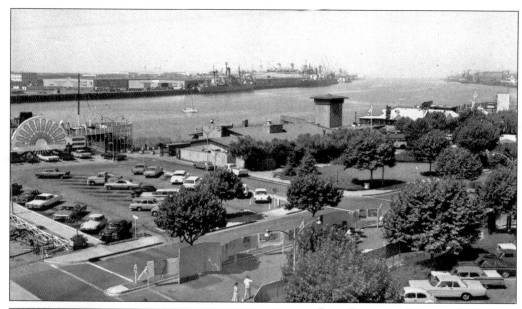

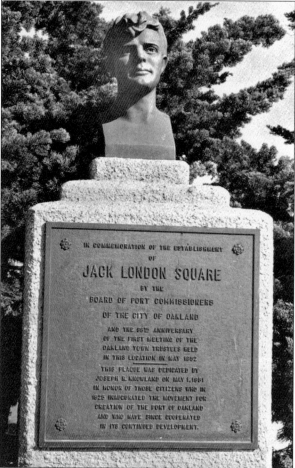

JACK LONDON SQUARE. In the late 1940s, Oakland's port commissioners, taking note of San Francisco's successful Fisherman's Wharf area, decided to redevelop their waterfront district between Broadway and Webster Streets by constructing attractively landscaped parking lots that would allow visitors to drive, park, and dine at the longtime eateries located in the vicinity. They also gave inducements to other restaurants to open nearby. On May 1, 1951, on the eve of the city's 99th birthday, Jack London Square was officially dedicated with the monument seen at left. Famed writer Jack London (1870–1917) frequented the docks and quays of the waterfront during his rough-and-tumble youth. London's rugged tales of survival in the Yukon wilderness continue to engage readers to this day, and visitors from around the world come to see what is left of his old haunts.

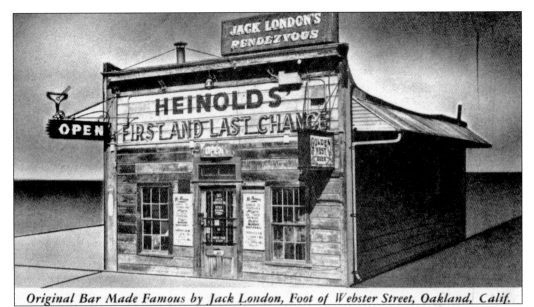

Original Bar Made Famous by Jack London, Foot of Webster Street, Oakland, Calif.

HEINOLD'S FIRST AND LAST CHANCE SALOON. This rustic, ramshackle bar has been in continuous operation since 1884. Young Jack London stopped in frequently to listen in on the tall tales recounted by the sailor crowd patrons, and proprietor Johnny Heinold is said to have loaned him the money to apply to the University of California. The saloon is listed on the National Register of Historic Places and is also a national literary landmark.

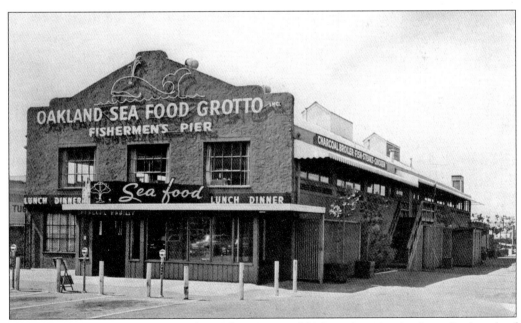

OAKLAND SEA FOOD GROTTO. Shown here is one of the longtime eateries down by the wharf area that would become Jack London Square.

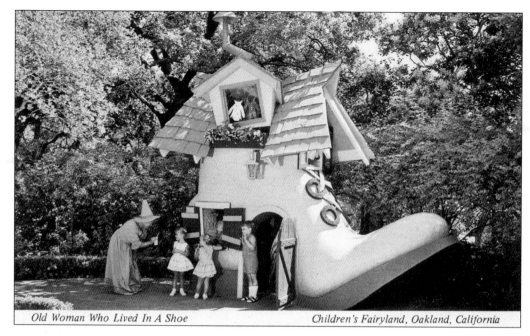

Old Woman Who Lived In A Shoe *Children's Fairyland, Oakland, California*

CHILDREN'S FAIRYLAND. In 1950, parks director William Penn Mott (no relation to Mayor Frank Mott) enlisted the aid of civic booster and garden enthusiast Arthur Navlet and others from the Lake Merritt Breakfast Club. They conceived of a special park in Lakeside with child-sized "Little Bo Peep" stage sets, a petting zoo, and costumed guides that were versed in all the Mother Goose rhymes. East Bay families soon flocked to the new park. The Breakfast Club continues to sponsor and maintain Fairyland to this day. Walt Disney was reported to have made more than one trip to Oakland to look over Children's Fairyland as he began work to build his own theme park in Anaheim, which opened a few years later in 1955.

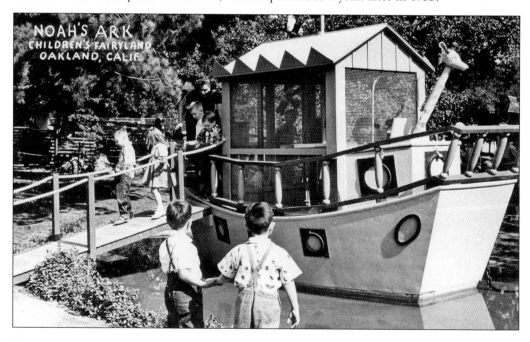

Dunsmuir House and Gardens Estate. In 1961, the city acquired the 75-acre historical estate of Mrs. I. W. Hellman with grants, city funds, and state highway right-of-way money, totaling $238,000. The secluded grounds, tucked away in the Oakland hills near the San Leandro border, contained an elegant, creamy-white mansion with pitched roof portico and pillared front entry. The 37-room mansion once belonged to Alexander Dunsmuir, son of a wealthy British Columbian industrialist. It was built in 1899, and later acquired by the San Francisco–based Hellman family for their private East Bay summer retreat. Since the early 1970s, a nonprofit group has been holding the property open for tours and events, especially the ever-popular and festive annual holiday weekends. The house and grounds have been used as a setting for motion pictures as well.

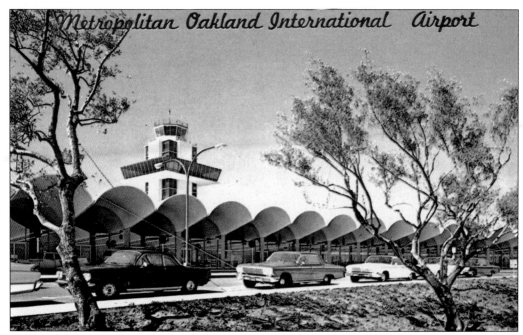

OAKLAND INTERNATIONAL AIRPORT TERMINAL. The 1962 dedication of a new runway and terminal, seen here, inaugurated the jet age at Oakland International Airport. The $5.2 million passenger terminal, with its unusual undulating roofline, was designed by Warnecke and Warnecke.

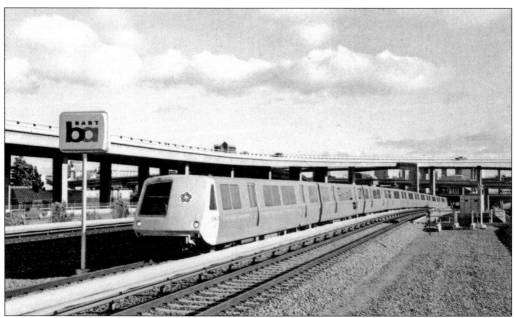

BART TRAIN. Since coming on line in 1972, passengers have traveled more than 22 billion miles on the 103–mile BART system.

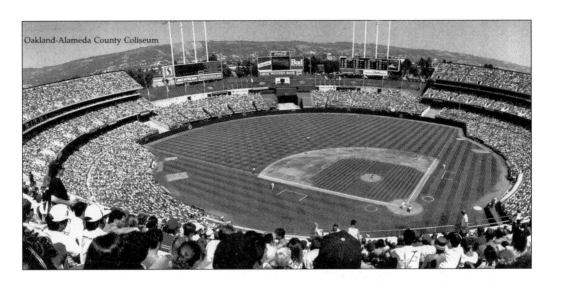

Oakland-Alameda County Coliseum

OAKLAND ALAMEDA COUNTY COLISEUM. This complex, completed in 1965, was designed by nationally recognized firm Skidmore, Owings, and Merrill. It is home to the Oakland Raiders, the Oakland A's, and the Golden State Warriors.

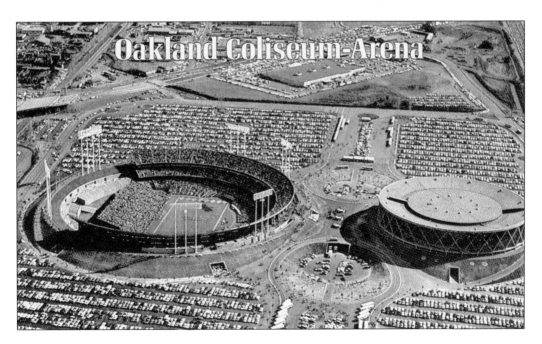

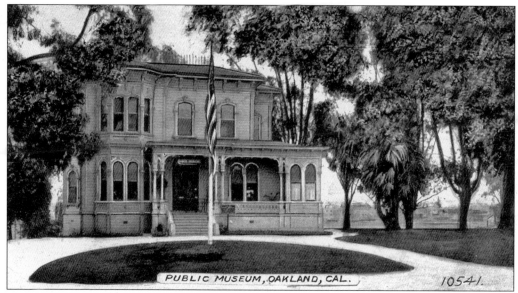

PUBLIC MUSEUM/CAMRON-STANFORD HOUSE. For 50-plus years, the Italianate villa on Lakeside Drive, built in 1876 by Dr. Samuel Merritt (see Chapter Two), served as the city's public museum. In the 1960s, desiring a more flexible and modern facility, city leaders put a bond measure on the ballot asking voters to approve $6.6 million in funds to construct a new museum. The old museum building was rescued by a dedicated group of community volunteers, who worked to restore it to reflect its glory days in the 1880s, when First Lady Lucy Hayes made a visit and was entertained there at a fashionable tea reception. The name for the new historic house museum was taken from two of the families who once lived there. It opened for regular tours in the late 1970s.

OAKLAND MUSEUM OF CALIFORNIA. A site at for the new museum was selected at Oak and Tenth Streets, a few blocks from the former location overlooking the lake. The complex covers four city blocks and was considered to be a milestone in contemporary museum design, garnering high praise from critics when it opened its doors in 1969. The winner of a nationwide design competition was the architectural firm of Roche and Dinkeloo. A series of levels and landscaped terraces lead to three different permanent galleries exploring the art, history, and natural aspects of the state of California. A great hall offers changing exhibits on a wide array of topics. A 2004 exhibit focused on the Vietnam War era and its impacts on the West.

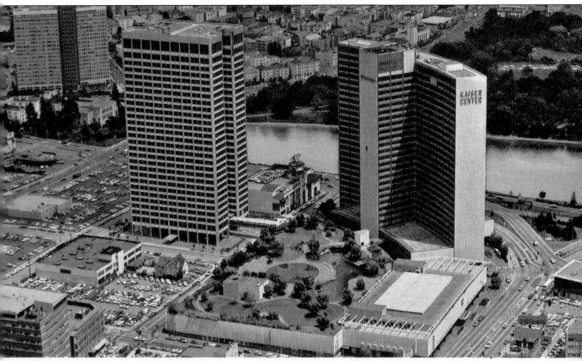

iiser Center, Oakland, Calif.

ROOF GARDEN, KAISER CENTER. In 1959, Kaiser Industries, the multinational industrial conglomerate founded by Henry J. Kaiser (1882–1967), acquired the former lakeside campus property of Holy Names College (see Chapter Six). The company's world headquarters building was erected on the site, 28 stories tall, sheathed in aluminum alloy (one of the company's products), and designed by prominent mid-20th-century architects Welton Beckett and Associates. One of the most unique aspects of the complex, besides its innovative curving facade, was a two-acre garden created on top of the complex's garage roof. It, too, earned widespread praise when it opened in the early 1960s and served as a prototype for other commercial building roof garden projects built elsewhere.

Montclair Library

MONTCLAIR BRANCH LIBRARY. The neighborhood district in the Oakland hills known as Montclair was one of the outlying areas that came into its own after World War II, when demand for housing resurfaced after the long hiatus caused by the Depression followed by the focus on winning the war. As Montclair developed, it became known for its quaint storybook-style cottages tucked in amidst evergreen trees and rustic gardens. The neighborhood library on Mountain Boulevard and the firehouse for Engine Company 24, although constructed a few years prior, are indicative of Montclair's charming storybook character.

Montclair Firehouse

MONTCLAIR FIREHOUSE. The firehouse, with its charming peaked roof and brick chimney, currently stands empty because it was determined that the structure is right on the Hayward earthquake fault, and therefore is not an appropriate location for emergency vehicles. It is hoped that another use can one day be found for the building that many consider the symbolic landmark of Montclair.

Eight

OAKLAND'S VANISHED LANDMARKS

Throughout America, thanks to collectors of historical postcards, once-gracious landmarks that are no longer standing can be viewed once again. Over the years in Oakland, the onslaught of progress has caused many distinctive buildings to be lost. This chapter is dedicated to this "gone but not forgotten" group of landmarks. Examples include club buildings, a courthouse, mansions, garden estates, and auto showrooms.

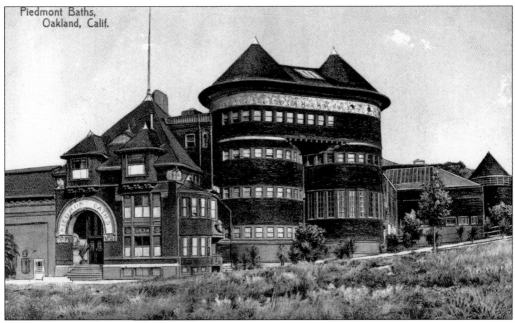

PIEDMONT BATHS. This fanciful Victorian-style structure, sheathed in redwood shingles, housed a public natatorium including indoor pools, a barbershop, and smoking rooms. It stood next to the powerhouse for the Piedmont Consolidated Cable Company, on Harrison Street. The cable company's boilers also heated the water used for the bathing pools. The water was drawn from nearby Lake Merritt. The baths closed, and the building was later demolished in the 1930s. The lot where it stood is still vacant.

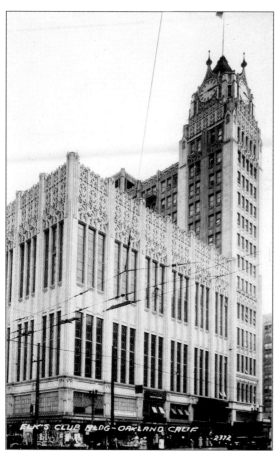

BUILDINGS BY WILLIAM KNOWLES, 1925. The Elks Club Building (left), designed by William Knowles, opened on Broadway and Twentieth Street in 1925, opposite the Emporium Capwell Department Store. It was demolished in 1966 and replaced by a modern office building. Knowles also designed the Athens Athletic Club (below), which also opened in 1925 and was where the East Bay's civic and business elite devoted time to exercise, relaxation, and fellowship. The building came down in 1977. The Ronald V. Dellums Federal Building now occupies the site.

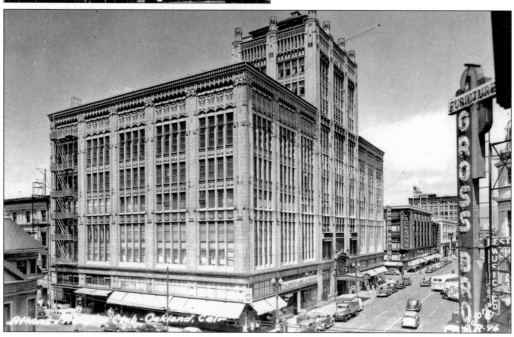

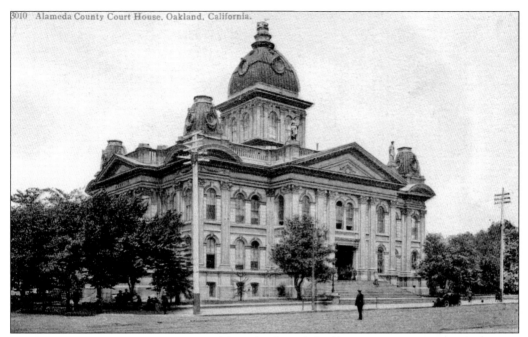

ALAMEDA COUNTY COURTHOUSE. Although Alameda had been a separate county since 1853, Oakland did not become the county seat until 1873. The courthouse building seen here, and the hall of records seen below, stood opposite each other on Broadway, in the block between Fourth and Fifth Streets. They were both later replaced by a new complex by the lake and came down in the 1950s. Today two county social services buildings stand in their place.

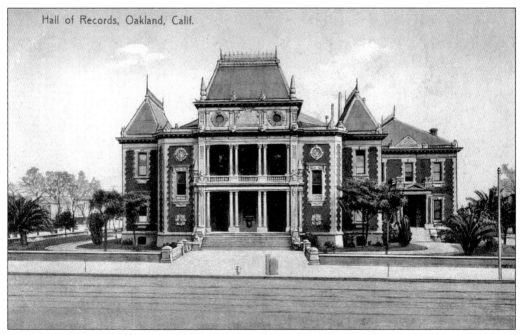

Hall of Records, Oakland, Calif.

ALAMEDA COUNTY HALL OF RECORDS.

3152 – Lake Merritt, from the Schilling Garden, Oakland, California.

SCHILLING GARDENS, C. 1900. The private gardens of spice merchant August Schilling overlooking the lake, near Jackson Street, would occasionally be open so the public could enjoy strolling the grounds. Although the Schilling mansion is no more, portions of the estate's garden still exist, tucked behind the 244 Lakeside Drive apartments. Below, a groundskeeper takes a break from his landscaping duties.

Park, Lake Merritt, Oakland, Cal.

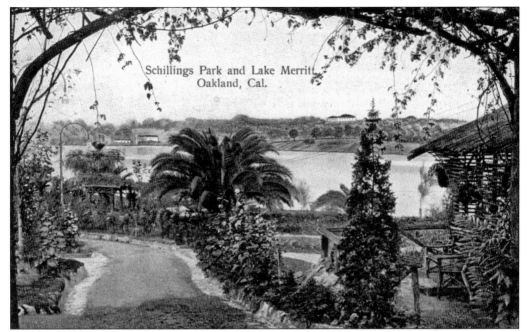

SCHILLING GARDENS. Remnants of the Schilling gardens can still be found in back of the 244 Lakeside Drive apartments (see Chapter Five). The Regillus stands where the Schilling mansion once was.

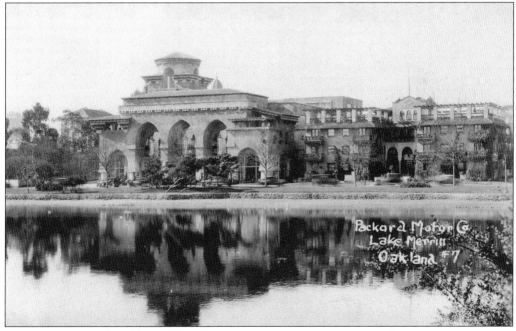

PACKARD MOTORS SHOWROOM. Famed architect Bernard Maybeck is credited with designing this elegant automobile showroom building, which occupied a prominent site next to Lake Merritt. It was demolished in the 1970s to make way for a parking lot.

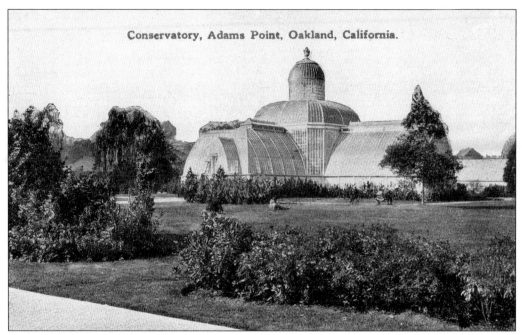

Conservatory, Adams Point, Oakland, California.

CONSERVATORY, HARMON ESTATE, ADAMS POINT. Measuring 75 feet in length and containing many rare plant specimens, the glass conservatory belonged to Comstock mining king A. P. Harmon, whose Oakland mansion on Webster Street neighbored the College of Holy Names. The conservatory was demolished to make way for the new Veterans Memorial Building (see Chapter Two).

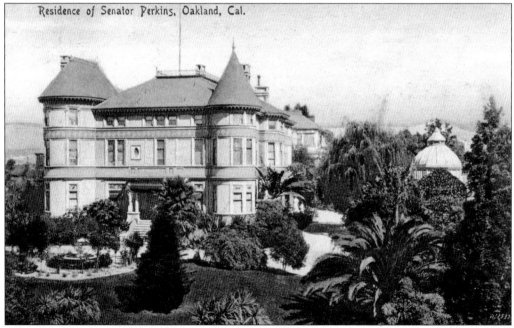

Residence of Senator Perkins, Oakland, Cal.

SENATOR PERKINS MANSION, ADAMS POINT. A number of the grand homes in the Adams Point District near Lake Merritt were demolished in the 1930s, 1940s, and 1950s to make way for apartment complexes. Such was the fate of the Perkins Mansion.

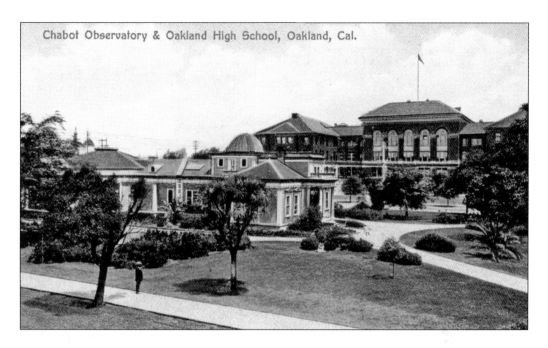

Chabot Observatory & Oakland High School, Oakland, Cal.

VIEWS OF CHABOT OBSERVATORY AND OAKLAND HIGH SCHOOL FROM LAFAYETTE SQUARE. Oakland High School once stood on Eleventh Street between Grove and Jefferson Streets, opposite Lafayette Square. Water company magnate Anthony Chabot donated funds for an observatory to be built in the park for the students to use. Neither building is still standing today. Oakland High has moved to Park Boulevard, and a new multimillion dollar Chabot Space and Science Center is now open in the Oakland Hills. The park, however, did receive a comprehensive renovation in the 1990s.

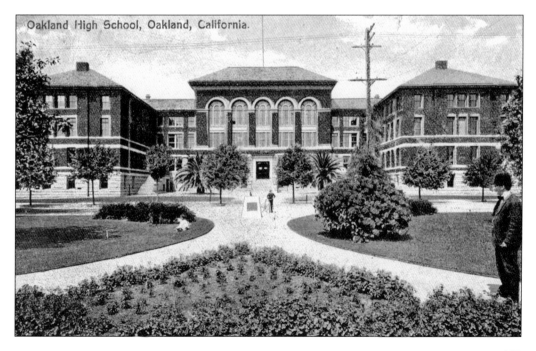

Oakland High School, Oakland, California.

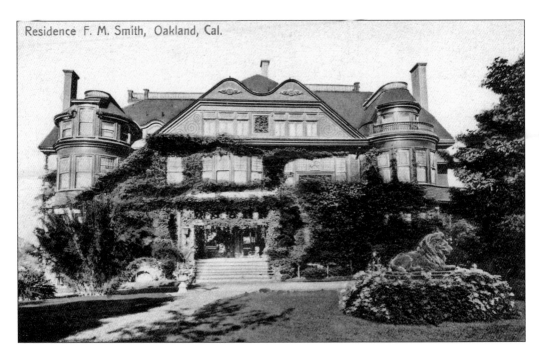

Residence F. M. Smith, Oakland, Cal.

ARBOR VILLA, ESTATE OF F. M. "BOROX" SMITH. Francis Marion Smith earned the nickname "Borax" from successfully extracting the mineral from Death Valley, thus establishing his initial fortune. After arriving in Oakland, he invested his money in real estate and public transit. Here are two views of his magnificent Arbor Villa estate, east of Park Boulevard The gracious mansion, witness to innumerable galas and parties, was designed by architect Walter J. Mathews. Following his death in 1931, Smith's extensive hillside property was subdivided for lots. As part of this redevelopment, the mansion was demolished.

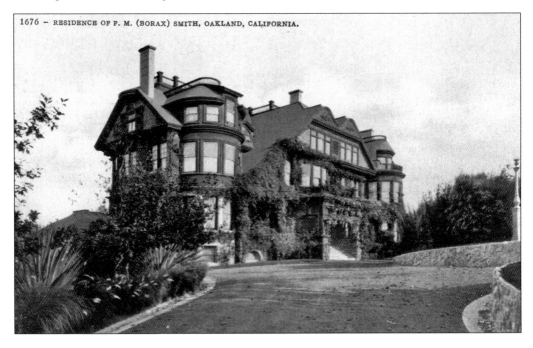

1676 – RESIDENCE OF F. M. (BORAX) SMITH, OAKLAND, CALIFORNIA.

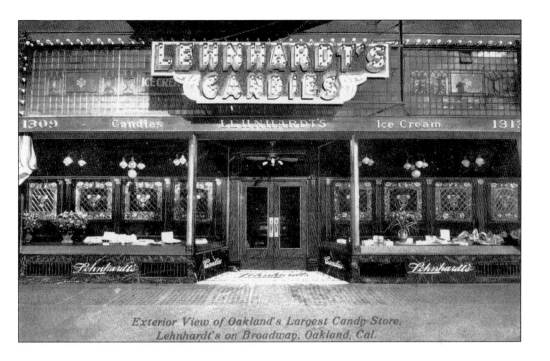

Exterior View of Oakland's Largest Candy Store,
Lehnhardt's on Broadway, Oakland, Cal.

LEHNHARDT'S CANDIES, BROADWAY AND THIRTEENTH STREET. Ernie Lehnhardt and his wife, Hattie, operated the store and fountain on Broadway from the 1880s until the 1930s.

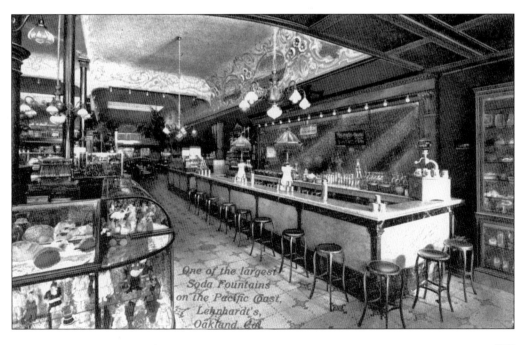

One of the largest
Soda Fountains
on the Pacific Coast.
Lehnhardt's,
Oakland, Cal.

I AM GOING THE LIMIT IN

Oakland

AND WISH YOU WERE HERE

WISH YOU WERE HERE! Although the sentiments here may have been mass-produced, they were heartfelt. Many heeded the message and made Oakland their home.

Well here I am in OAKLAND, CAL.
 Enjoying its sights and cheer;
Everything's great, and I'm feeling first rate
But, O, how I wish you were here!